IMAGES
of America

ELEANOR ROOSEVELT'S
VALKILL

D0999281

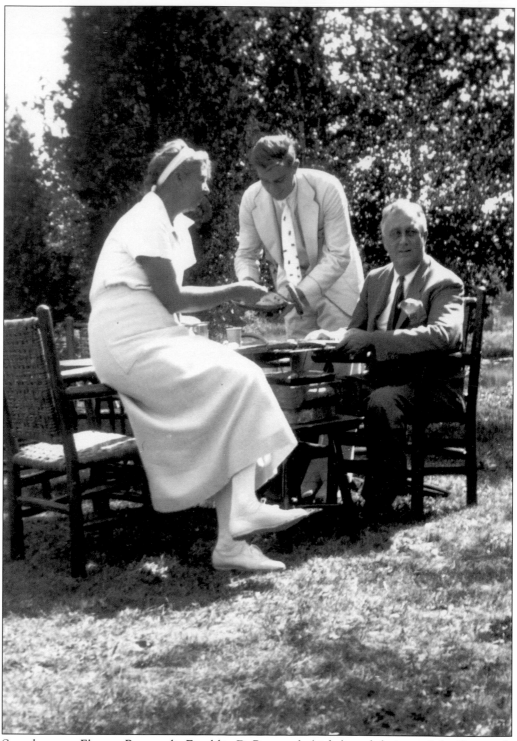

Seen here are Eleanor Roosevelt, Franklin D. Roosevelt (right), and their son John Roosevelt at Valkill. (National Park Service.)

IMAGES
of America

ELEANOR ROOSEVELT'S VALKILL

Richard R. Cain

ARCADIA
PUBLISHING

Published by Arcadia Publishing
Charleston, South Carolina

Printed in the United States of America

Library of Congress Catalog Card Number: 2002108554

For all general information contact Arcadia Publishing at:
Telephone 843-853-2070
Fax 843-853-0044
E-mail sales@arcadiapublishing.com
For customer service and orders:
Toll-Free 1-888-313-2665

Visit us on the Internet at www.arcadiapublishing.com

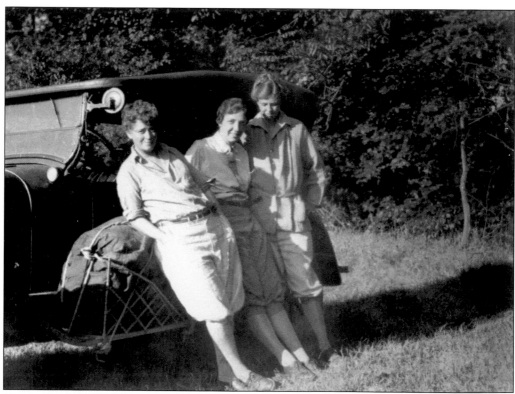

Nancy Cook (left), Marion Dickerman (center), and Eleanor Roosevelt are about to leave on a camping trip. (NPS.)

CONTENTS

ACKNOWLEDGMENTS

I would like to personally thank the following people, without whose help this publication would have remained a dream: Anne Jordan, Frank Futral, and Michelle Ballos of the National Park Service at Hyde Park for their assistance and for providing photographs; the staff at the Research Room of the National Archives at the Franklin Delano Roosevelt Library; Kathy Gaffney for photographs; Janet Sommerville for keyboarding and computer expertise; and my wife, Lorraine, and family for their patience and compassion with my passion. I thank all for their encouragement. I also thank Arcadia Publishing for being the first to publish a photographic history of Eleanor Roosevelt's Valkill site. Most of the photographs included here are being published for the first time and have come from six sources. The first time these photographs appear in the book, the lender is credited by his or her full name. After, each lender will be credited with the following abbreviations: Clifford M. Smith (CMS), Richard R. Cain (RC), Kathy Gaffney (KG), the National Archives of the Franklin Delano Roosevelt Library (FDRL), the National Park Service (NPS), and John Golden (JG).

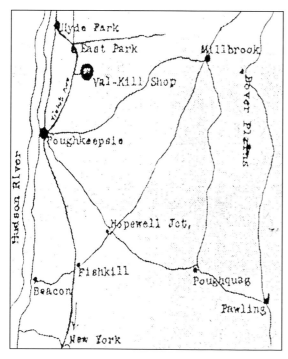

This map from a Valkill Industries sales brochure shows the site location off Violet Avenue, now Route 9G, in the town of Hyde Park. (NPS.)

INTRODUCTION

While driving in Hyde Park to the National Park Service home site of Eleanor Roosevelt, one can not help but notice the people, buildings, businesses, homes, residential developments, and traffic of an area that has not escaped the population development and growth characteristic of a fringe suburb of New York City.

A large, wooden unobtrusive sign denotes the main driveway entrance to the site. The calm drive into the parking area immediately contrasts with the hubbub of the state highway. Here, it is quiet. There is a large pond with geese, mallard ducks, and fish. Evidence of deer is present. There are fields, woods, butterflies, purple loosestrife, goldenrod, and daisies.

It is easy to understand why Eleanor Roosevelt built her home here. She had written, "The greatest thing I have learned is to come home again." People come here to sit, stroll the paths, or wander among the buildings. It is easy to feel the calm and peace that exists here.

Taking a tour through the stone cottage or the converted furniture factory, a second home of Eleanor's, one is virtually struck by the simplicity and the homey feel of the buildings and furnishings. Eleanor Roosevelt's home is being furnished as closely as possible with items that she owned and used. It is difficult to believe that this is Eleanor Roosevelt's home. One might expect a larger, more grandiose style. The contrast is remarkable, but for those who knew or studied the Roosevelts, this site embodies their heart and soul. It is possible to believe that Eleanor is in the room or on the lawn with you.

Another contrast can be made of the site itself. While Eleanor came here to relax and regenerate, there were many years when this site itself was busy with activity. She shared the site with two other good friends who were active people as well. Political people from all levels of government were invited here. World leaders were entertained here. A small Arts and Crafts–style furniture factory and forge operated here for 10 or so years. The workers were coming and going, and caretakers and children lived here. Eleanor's five children and their children stopped by frequently.

Eleanor Roosevelt's Valkill is born of my passion for my own family heritage at Valkill, including several generations who were involved there. There is a chapter about Woodlawns Farm, which my great-grandparents rented from Franklin Roosevelt. There are many photographs of my grandparents and mother, who lived and worked at Valkill. The genesis of this book comes from roughly 200 photographs in my grandparents' scrapbooks of this site, its people, and its events from 1925 to 1947. The National Park Service, the Franklin Delano Roosevelt Library, and others have provided many other photographs seen here.

Included are chapters of royal visitors to Top Cottage, located near Valkill. A chapter is devoted to the famous introduction to the British king and queen of the hot dog. Most people do not realize until they visit the site that Eleanor Roosevelt was part owner of a furniture and pewter factory there. Included are chapters explaining this undertaking and representative photographs of the products. These items have become highly sought after collector's pieces.

It is my intent with this photographic history of the Valkill site to inform, entertain, and enlighten readers. There are many stories that give interesting details of Eleanor Roosevelt's life and her home site.

Through the efforts of the National Park Service, Eleanor Roosevelt at Valkill, the Franklin and Eleanor Roosevelt Institute, and others, Eleanor Roosevelt's ideas and beliefs will continue to survive. I encourage all to visit Valkill to relax, to regenerate, and to walk with Anna Eleanor Roosevelt.

One

ENVIRONS

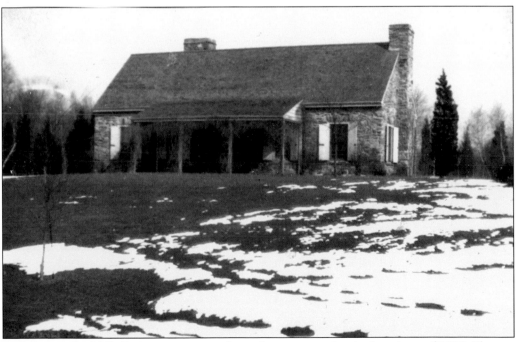

Seen here is the Valkill stone cottage not long after construction in the winter of 1926. Eleanor Roosevelt, Nancy Cook, and Marion Dickerman shared the home. It was a place of quiet solace and rest for Eleanor Roosevelt, away from Franklin Roosevelt's main home in Hyde Park. (Clifford M. Smith.)

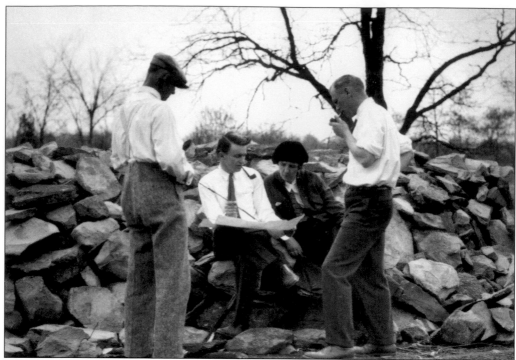

Architect Henry Toombs reviews a set of plans with Marion Dickerman and others before the construction of the stone cottage at the Fallkill Creek site on the Roosevelt estate in Hyde Park. (NPS.)

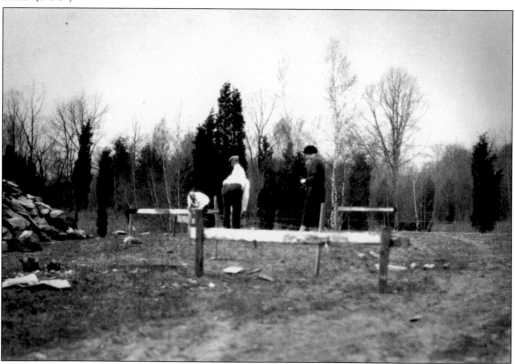

Batten boards and strings are set to lay out the foundation and for excavation. (NPS.)

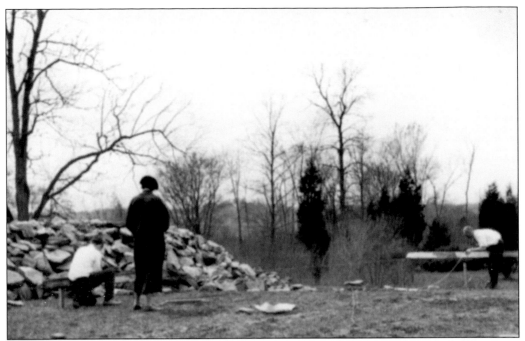

Franklin Roosevelt assisted with the design of the cottage. He was a local history buff and was enamored of the Dutch Colonial–style structure composed of natural fieldstone. Roosevelt assisted with other building projects in Dutchess County, including several post offices and schools that were all composed of fieldstone. (NPS.)

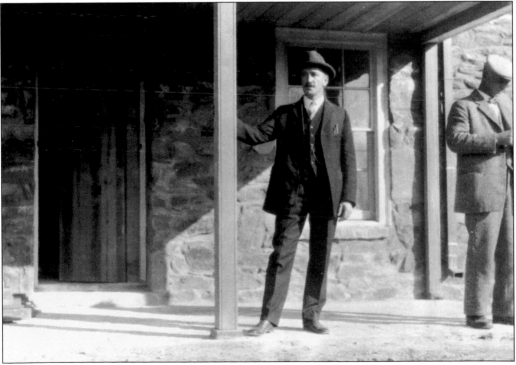

Henry Toombs inspects the work of the front porch. (NPS.)

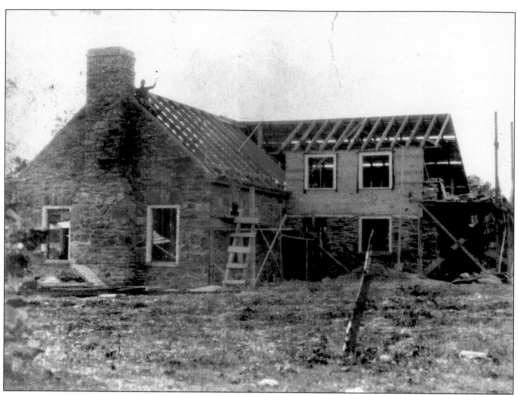

Here, the stonework is complete, and the roof rafters and sheathing are being installed. Work was started in 1925. (NPS.)

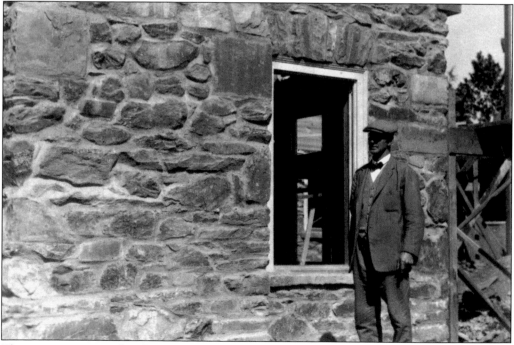

The stone mortar work is being inspected. (NPS.)

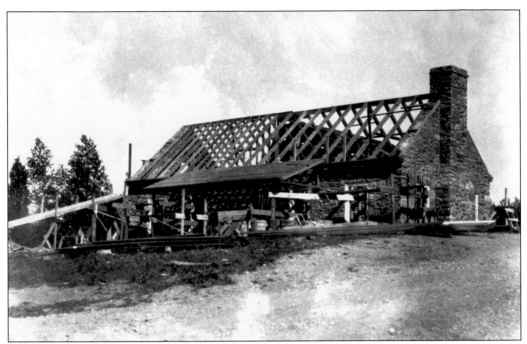

The east end has a nice stone fireplace. This building is actually the modified second plan, with slightly larger dimensions and a differing floor-plan layout from the first plan. Both plans allowed for a wood shop to be included within the building. (NPS.)

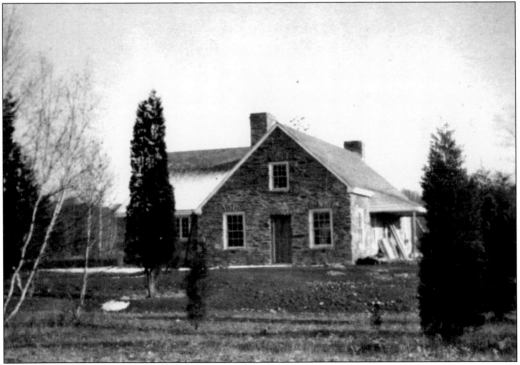

This photograph, taken in the early spring of 1926, shows the finished building with a rough-graded side yard, an unfinished porch, and without window shutters. (NPS.)

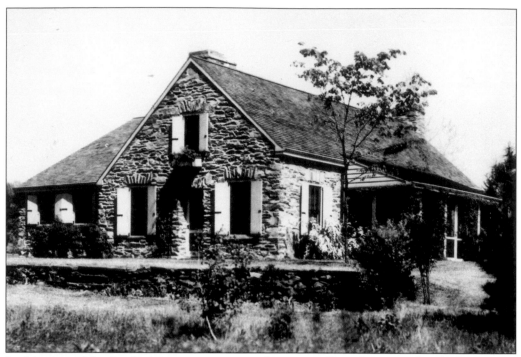

In this view of the finished stone cottage, note the stonewall on the west side, which provided level lawn by the side door. (NPS.)

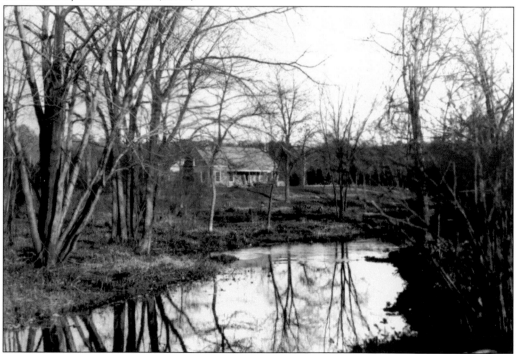

Seen here is the stone cottage in the early spring of 1926. This view was taken before the Fallkill Creek had been dredged to produce a pond. This had been a favorite picnic spot for Eleanor and Franklin Roosevelt and their friends and family. (NPS.)

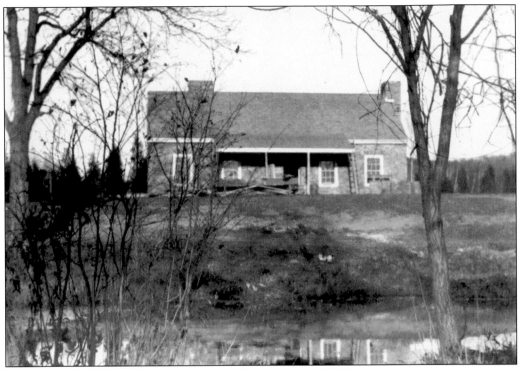

This is a front view of the stone cottage before dredging. (NPS.)

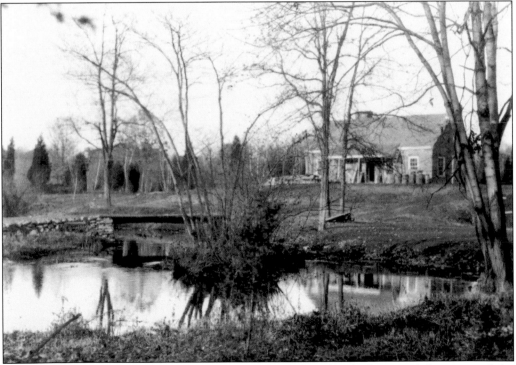

Seen here is a view to the southeast of the bridge before the dredging and damming of the creek. (NPS.)

Seen here is the first swimming pool built by the pond edge near the bridge and southeast of the stone cottage. Water was piped from the creek. The site work here is incomplete. This pool was filled in when a second pool was built by the house. (NPS.)

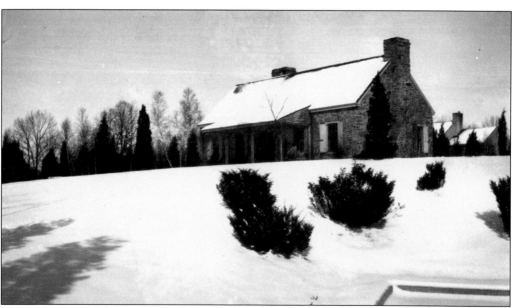

This view shows the finished stone cottage and the corner of the first pool and shrub plantings. Note the second building, which housed a furniture factory, behind the stone cottage. The original plans called for a workshop in the home, but there was insufficient room and a separate building was constructed. (NPS.)

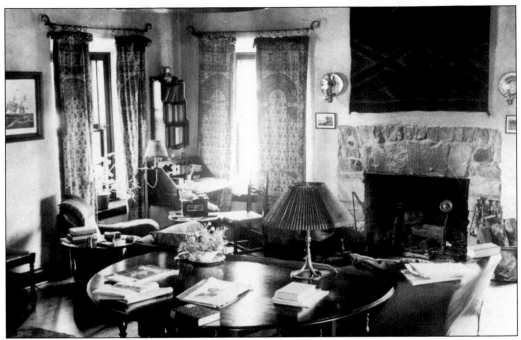

This interior view of the great room at the stone cottage reveals a wooden table, chairs, a desk, and a bookshelf that were constructed in the furniture factory. Many of the furnishings throughout the house were constructed at the factory on site. (NPS.)

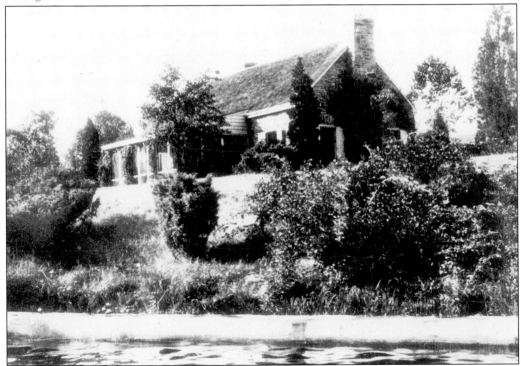

This is an early view of the stone cottage with the original swimming pool by the Fallkill Creek. This photograph was later used on the front of a Valkill Industries sales catalog. (CMS.)

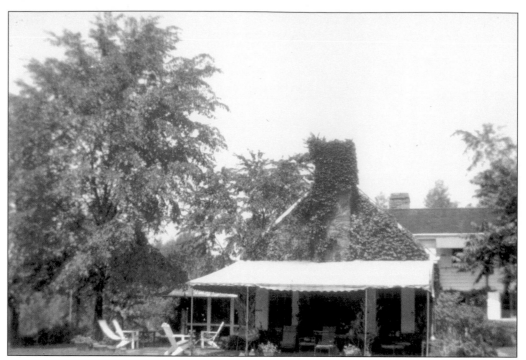

Seen here is an east-end view of Valkill Cottage during the late summer. The second pool was constructed here, and many Roosevelt family days were spent leisurely enjoying the solitude of the area. (CMS.)

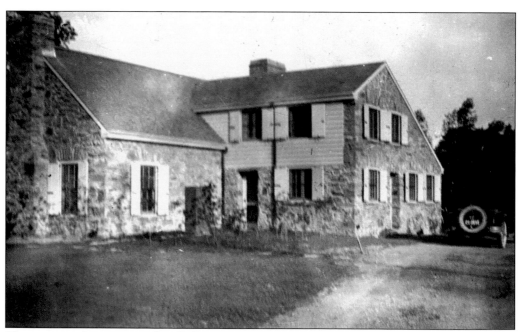

This is a northeast view of Valkill stone cottage before the loggia, patio, and gardens were added to the north. (CMS.)

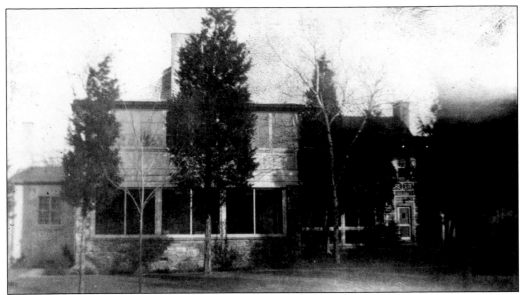

The Valkill Industries workshop building behind the stone cottage was constructed in 1926 and was added to several times as the furniture business expanded. It later served as Eleanor Roosevelt's Valkill cottage home after the 1938 failing of the crafts business. (CMS.)

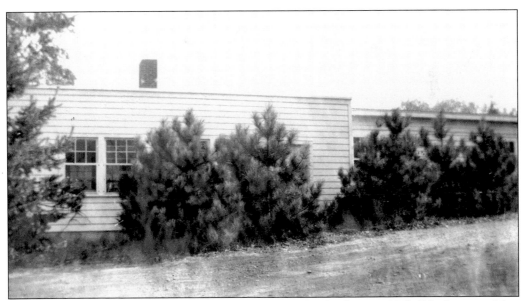

This was originally constructed as a separate building for the forge at Valkill Industries. After this business failed in 1940, it became the playhouse for Roosevelt grandchildren, who had many happy times. (CMS.)

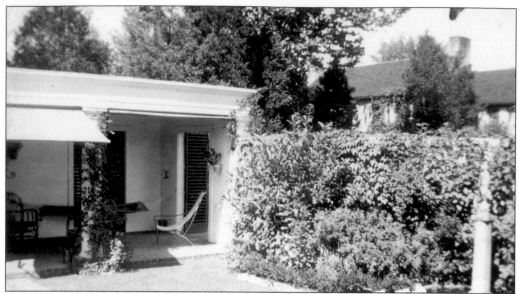

Seen here is the end of the loggia by the gardens at the north end of the stone cottage. (CMS.)

After construction of the stone cottage, the three ladies continued developing the site by adding hedgerows, gardens, fences, and the loggia. Clifford Smith was the head gardener at the time. (CMS.)

This is a view of the gardens behind the stone cottage. (CMS.)

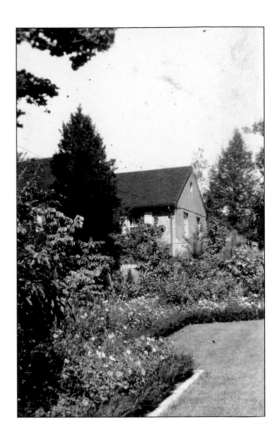

Seen here are more of the gardens located behind the stone cottage. (CMS.)

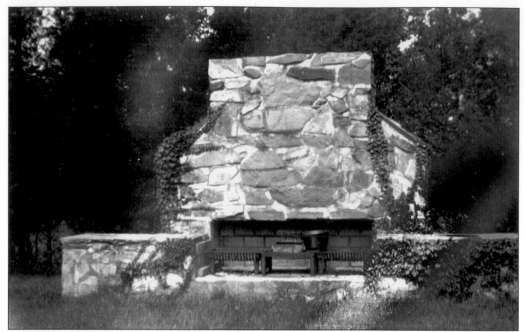

To the southwest of the cottage, by the pond, a stone picnic fireplace was built. Valkill cottage was built because of an inspiring 1924 picnic at the site. Nancy, Eleanor, and Marion wished to enjoy the site year-round, and Franklin Roosevelt consented to build a home there, offering life-tenancy rights to the three women. (CMS.)

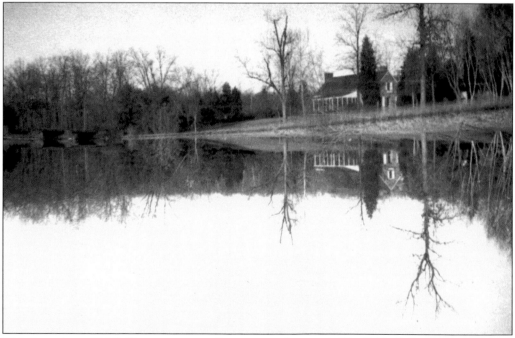

This is a view of Valkill stone cottage from across the pond. The Fallkill Creek was dredged, and a small dam was placed at the bridge to form the pond. Today, loosestrife and other water plants grow along the edges. (CMS.)

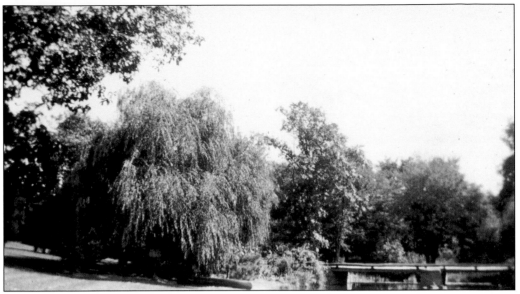

Seen here is a view of the bridge and willow tree. (CMS.)

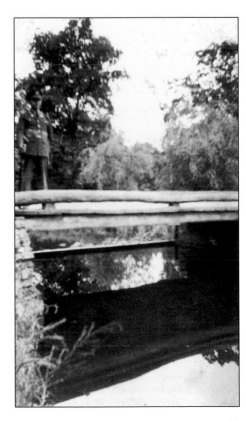

This is a view of the bridge and the dam. (CMS.)

The second pool and lawn were located at the east end of the stone cottage, where the badminton court was. (CMS.)

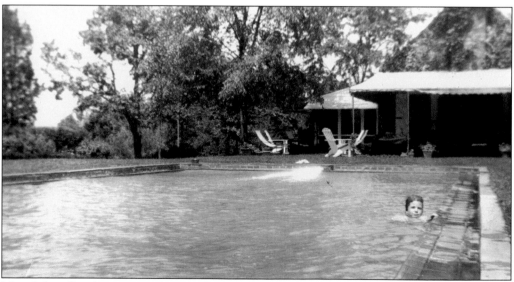

Muriel Ann Smith is seen in the president's pool at Valkill. Franklin Roosevelt would come here to swim, as he had no pool at his main house on Route 9, or the old Kings Highway. (CMS.)

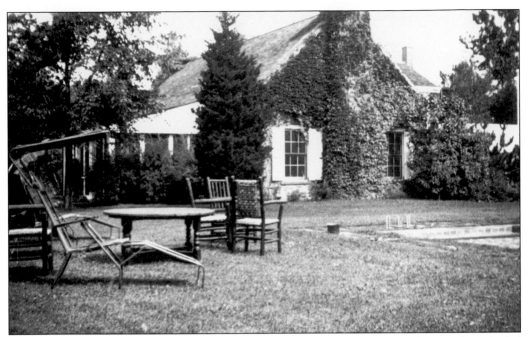

This later view of the pool, *c.* 1939, shows the stone cottage, a structure in the Dutch Colonial style. (CMS.)

Plants grown in this greenhouse, which is north of the main house, supported the gardens. (CMS.)

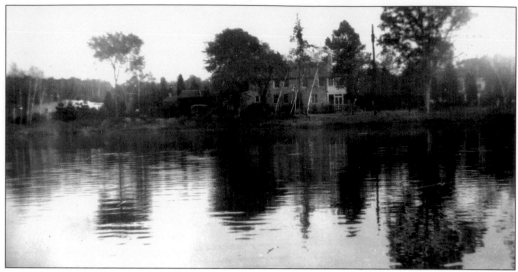

This photograph was taken from a boat on the pond, looking toward the furniture factory building. (CMS.)

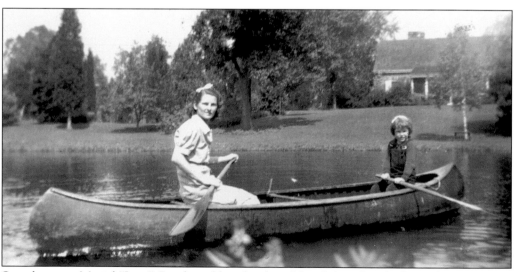

Seen here are Muriel "Joan" Smith and her daughter Muriel Ann Smith. (CMS.)

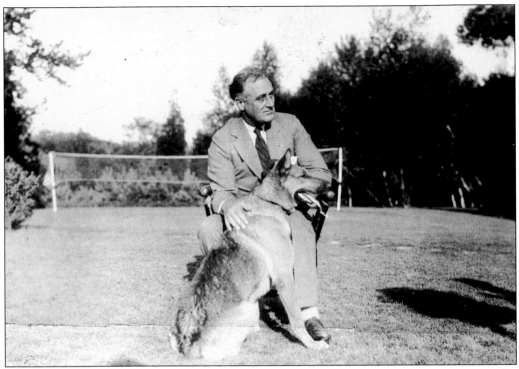

Franklin Roosevelt is seen with Dean, a German shepherd, on August 13, 1929. Dean was the pet of Nancy Cook and Marion Dickerman. (CMS.)

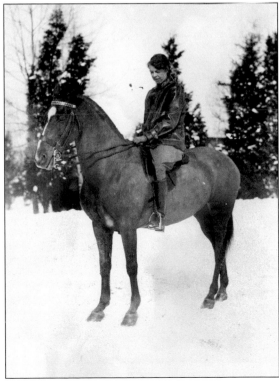

Eleanor Roosevelt enjoys winter exercise on horseback at Valkill. (CMS.)

Shirley Temple visits Eleanor Roosevelt at Valkill. (CMS.)

Many other dignitaries, politicians, and famous people visited Valkill, where Eleanor and Franklin did most of their entertaining. In the center is Shirley Temple. (CMS.)

Two

WOODLAWNS

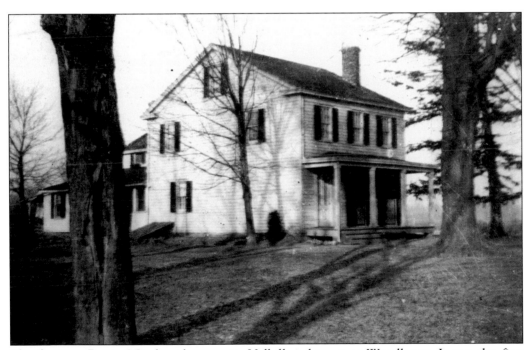

The farm on Route 9G, directly opposite Valkill, is known as Woodlawns. It was the first property owned directly by Franklin Roosevelt. Moses and Hattie Smith rented this farm from Roosevelt in April 1920 and stayed until 1947. This view, looking northwest, was made famous by an Olin Dowes drawing that was published in 1949. The farmhouse was demolished in 1974. Some people saw it as an old farm by the road, but others knew it as much more. (CMS.)

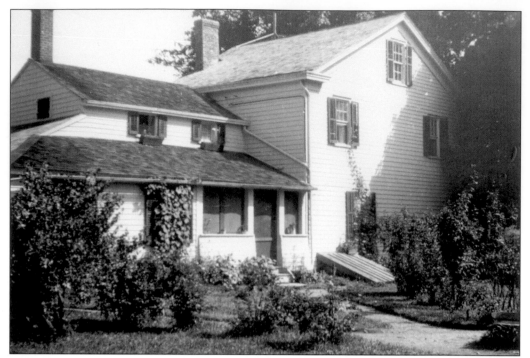

This is a southwest view of Woodlawns, which Roosevelt bought from Willis and Annie Bennett in 1911. It was Roosevelt's first property purchase. He had an interest in forestry, conservation, and the use of natural resources. Trees were planted to stabilize soils, and woodlots were maintained for lumber. The farm produced the usual crops and livestock. (CMS.)

Seen here are Moses and Hattie Smith at Woodlawns in 1925. They had four sons—Clifford, Arthur, Woodrow, and Kenneth. Moses became good friends with Franklin and Eleanor Roosevelt while he and his family were tenants on the farm. Roosevelt would often stop by and talk with "Mose" about local issues. One such discussion about a family that was too poor to heat their home one winter, causing the family to perish, inspired Roosevelt's vision for the current Social Security system. (CMS.)

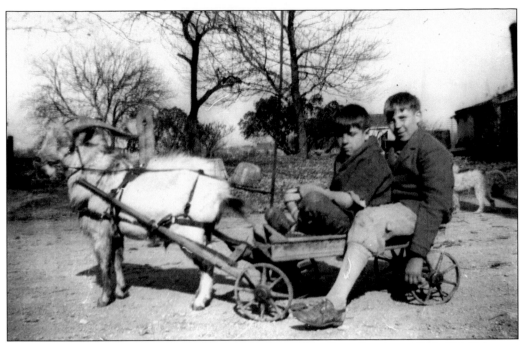

Fancy transportation was used by young Kenneth and Woodrow Smith, *c.* 1928. (CMS.)

Woodlawns farmhouse was also the site of Roosevelt's homecomings to Hyde Park. During the summers of his presidency, the Homecoming Club would decorate the house, West Point's U.S. Military Academy Band would play, and Roosevelt would speak about the important political topics of the day. (CMS.)

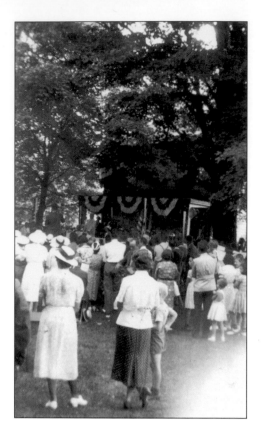

The house would be decorated with flags and bunting. The Secret Service would come a day or so in advance to interview the Smith family and inspect all of the rooms and contents of the home to ensure the president's safety. (CMS.)

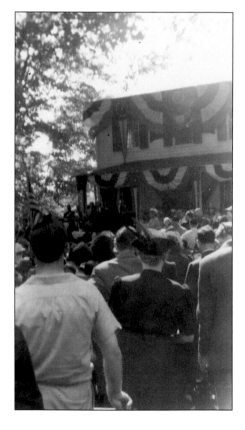

In September 1943, many residents of Hyde Park and Dutchess County were in attendance to welcome Roosevelt home again and to hear him speak. Often times, he would talk about local issues as well as national concerns. (CMS.)

Seen is a closer view of the podium and Roosevelt. The press would attend to make quick report of any newsworthy item. While Roosevelt was in Hyde Park, the press would stay at the Nelson House Hotel in Poughkeepsie. (CMS.)

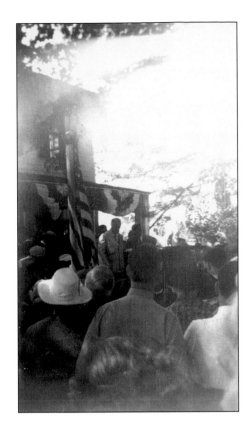

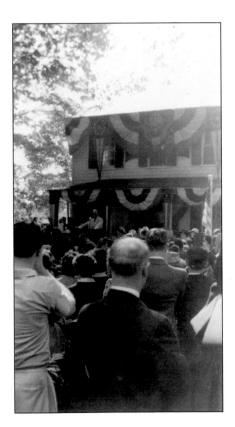

Roosevelt is seen at the podium in September 1943. (CMS.)

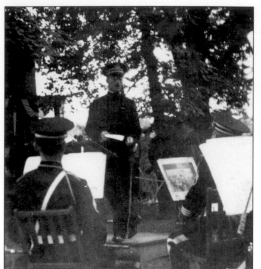

The U.S. Military Academy Band, from West Point, would bus up and play for the occasion. A John Philip Sousa march or other patriotic songs would inspire listeners. (CMS.)

The farm animals at Woodlawns were also keenly interested in what the president had to say. (CMS.)

Three

NORWAY

The prince and princess of Norway visit the Roosevelt estate. It was not uncommon for Franklin and Eleanor to entertain foreign heads of state and dignitaries in Hyde Park. (CMS.)

Program

ON THE OCCASION OF THE VISIT OF

THEIR ROYAL HIGHNESSES
THE CROWN PRINCE AND CROWN PRINCESS
OF NORWAY

TO

PRESIDENT AND MRS. ROOSEVELT

AT

HYDE PARK, N. Y.

ON

Saturday, April 29, 1939

This is the front cover of the program for the visit of the prince and princess of Norway to Valkill on April 4, 1939. The Smith family and other Hyde Park residents were invited to attend. (CMS.)

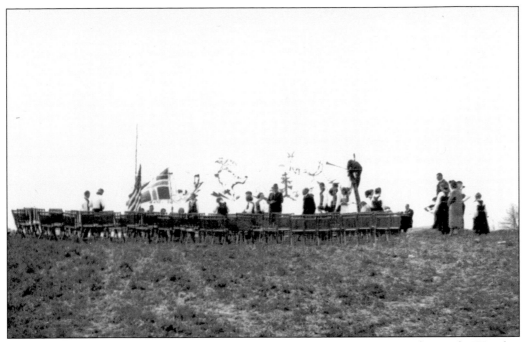

A wooden dance platform was constructed in a clearing near Top Cottage to the south. Wooden folding chairs were placed for viewing by the guests. Visitors were admitted by invitation only and had to be screened by the Secret Service. (CMS.)

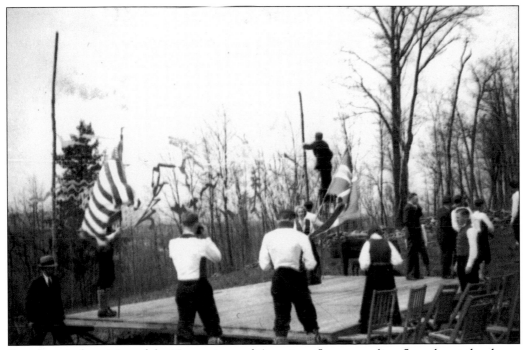

Seen here is the raising of the Norwegian and American flags on sapling flagpoles at the dance platform. (CMS.)

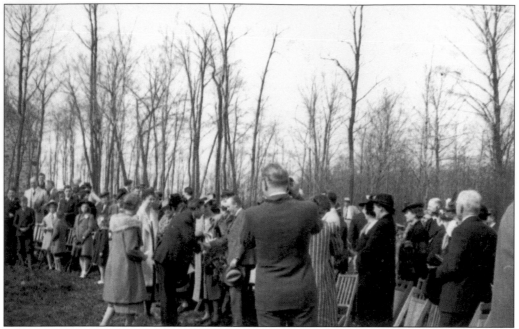

Visitors to the Norwegian dance and song festival queue for seats and await the arrival of the Norwegian heads of state. (CMS.)

The Norwegian Folk Dance Society of New York arrives at the site. This group consisted of Norwegian Americans who performed the folk dances of their homeland. Their mission was to "transplant and carry on in America some of the folk culture of the old country." (CMS.)

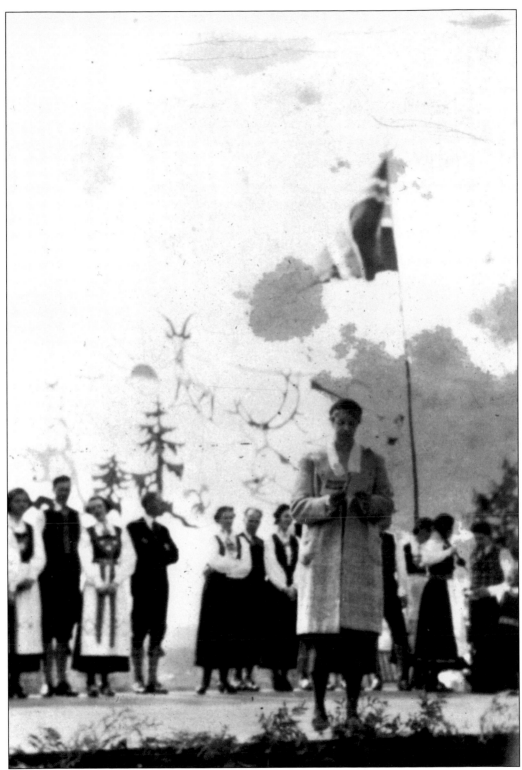

Eleanor Roosevelt speaks at the dance platform. (NPS.)

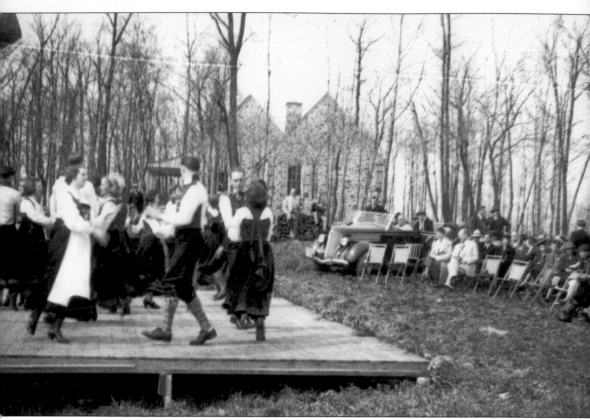

Among the festivities was the Norwegian folk dancing near Top Cottage. This newly constructed home was to be Roosevelt's retirement location. Top Cottage is located about a quarter mile from Valkill cottage on the estate. It is now open to the public. Franklin Roosevelt is in his car, watching the dancers. (CMS.)

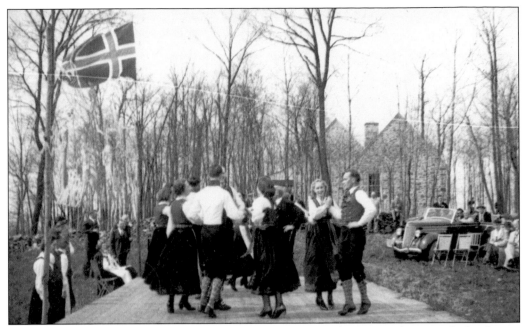

The dancers are seen in action at Top Cottage. It was easiest for Roosevelt to watch the dances from his car. This is because of his polio handicap and the uneven terrain for wheelchair use. Roosevelt had security and Secret Service protection, but times were different then as he felt secure enough to be shoulder to shoulder with his neighbors and friends. (CMS.)

Following the festivities at Top Cottage, the royal highnesses drove down the hill to the Valkill stone cottage for some personal time with the Roosevelts. These are the children of the royal family. The son is Prince Harold. (CMS.)

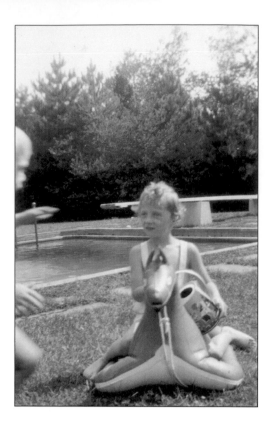

Prince Harold is seen by the new pool. It looks like April in New York may have been too cold to be in the water. (CMS.)

These appear to be cakes decorated with the country flags. (CMS.)

Four

ENGLAND

PROGRAM

Let It Be Beautiful *H. B. Alexander*	Indian Sign Talk
Romance Legend *Seneca*	The Blue Duck (an Ojibway Chant) . . . *L. Sarrett*
Lullaby *Dakota*	Indian Corn Ceremony *Te Ata*
PRINCESS TE ATA	PRINCESS TE ATA

———

———

Sun Rise Call (Chant of the Zuni High Priest)
Head Dress of Pheasant and Cock Feathers and Feather
Robe of Zuni Chief.

Chi Sano Kowa Kayo (Choctaw Love Song) . *Ish-Ti-Opi*

Old Woman Weaver *Thurlow Lieurance*
(Arranged by Ish-Ti-Opi)

Traditional beaded and fringed white buckskin costume
common to all North American Indians, particularly
glorified by the Sioux.

ISH-TI-OPI

Canoe Song (Shanewis) . . . *Charles Wakefield Cadman*

Potato Song (Navajo) *Traditional*

Zuni Blanket Wooing Song (Arranged by Ish-Ti-Opi)

Navajo Costume and Traditional War Bonnet of Eagle
Plumes.

ISH-TI-OPI

On June 11, 1939, two months after the Norwegian royal visit, King George and Queen Elizabeth of England visited Valkill and Top Cottage. This was the famous introduction of British royalty to the American hot-dog picnic. The royals sat on an extended front porch at Top Cottage. Shown is the program of the Native American cultural presentation after the picnic. (CMS.)

Franklin Roosevelt had commissioned Henry Toombs to design his retirement retreat, Top Cottage. It was also made of fieldstone in the style of Dutch Colonial architecture. Roosevelt had decided to give his ancestral home to the federal government as a museum and had plans to build a presidential library near his home. He expected this new home to be his retirement retreat. (CMS.)

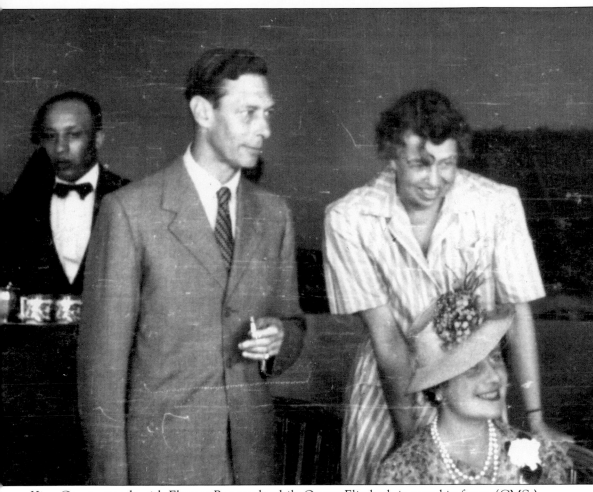

King George stands with Eleanor Roosevelt while Queen Elizabeth is seated in front. (CMS.)

Queen Elizabeth is enjoying the occasion. Harry Johannesen was the official photographer for the event. There were to be no cameras allowed, but the Smiths, as well as other people, managed to snap a few photographs. (CMS.)

It was a quiet, intimate gathering of 150 people. No reporters were allowed. (CMS.)

Here, drinks are served to the queen. The beverages consumed were beer, iced tea, iced and hot coffee, and soft drinks. A considerable amount of lime juice was consumed. To the queen's left sits Roosevelt. (CMS.)

Queen Elizabeth enjoys conversation with Secretary of the Treasury Henry Morgenthau. (CMS.)

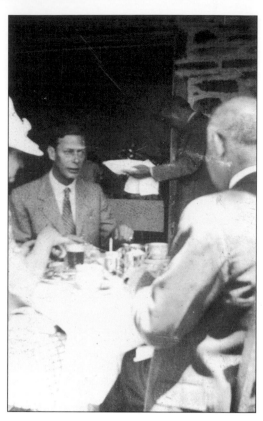

King George VI is in conversation with Mrs. Morgenthau and Herbert H. Lehman, the governor of New York. (CMS.)

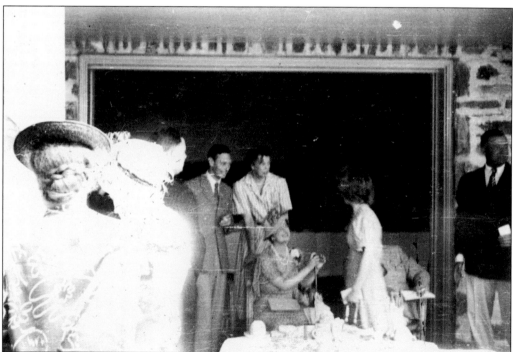

The king and queen are seen with Eleanor Roosevelt and others on the front porch. (CMS.)

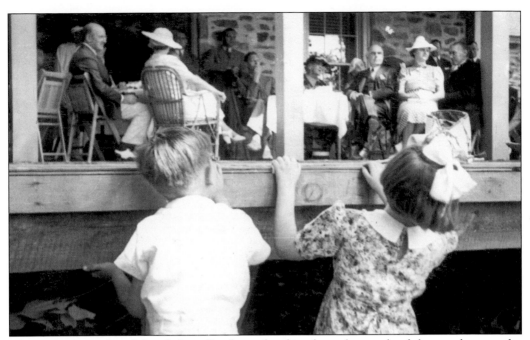

The author's mother, Muriel Ann Smith, and a friend sneak a peek of the royals over the extended front porch. (CMS.)

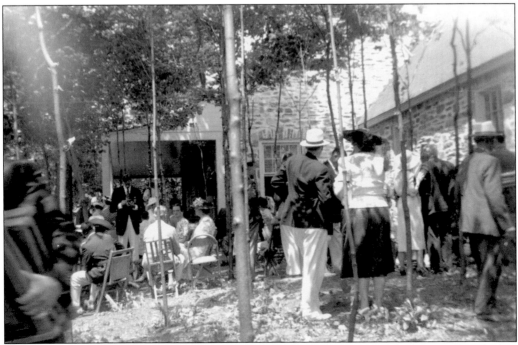

The local invited guests were seated at tables with folding chairs around the lawn and yard areas adjacent to the front porch. (CMS.)

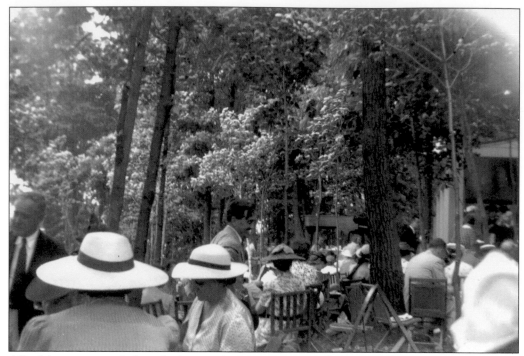

All of the guests, including the king and queen, were served on paper plates. They were treated to a customary American summer meal. This event has become known as the hot-dog picnic. According to news reports of the day, however, the menu also included pork and beans, ham, turkey, and tomato salad. (CMS.)

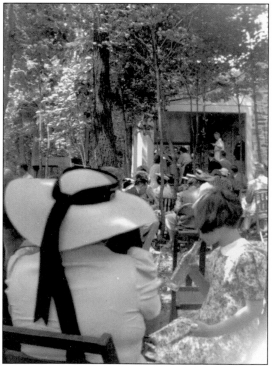

The head table seated the king and queen, the Roosevelts, some family members, Governor Lehman, and other politicians of the day. Local Roosevelt and Valkill employees who attended were Moses and Hattie Smith and their sons Woodrow and Kenneth, Clifford and Joan Smith, and Arthur and Grace Smith. Seen on the right is Ann Smith. (CMS.)

Members of the Berge family were Mr. and Mrs. Otto Berge, Helen and Doris Berge, and Mr. and Mrs. Arnold Berge. Members of the Johannesen family were Nellie, Roy, Roy's wife, Harry, and Harry's wife. Also seen are Mr. and Mrs. Plogg, Frederick Hedgecock, and others. All were formally presented to the king, queen, and the Roosevelts. All mingled freely. The picnic had a relaxed, homey atmosphere. (CMS.)

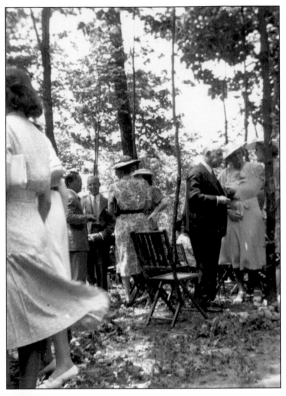

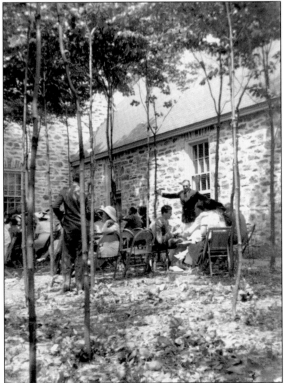

Roosevelt chauffeured the king and queen to his home on Route 9 for the day in his hand-controlled car. He drove them throughout his estate. After the picnic, they stopped for a while at Valkill stone cottage for a swim in the pool. (CMS.)

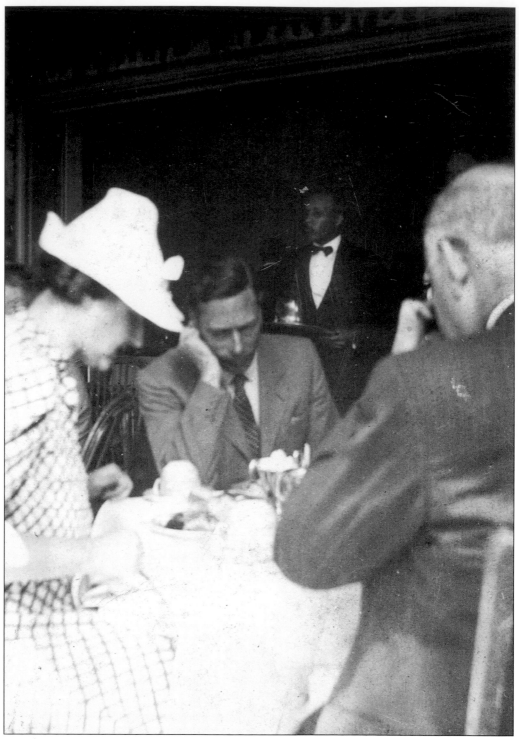

Seen here is King George, perhaps pondering conversation or the worsening European situation leading soon to World War II, or perhaps he is wondering what a hot dog is and what to do with it. (CMS.)

Guests enjoy the picnic. (CMS.)

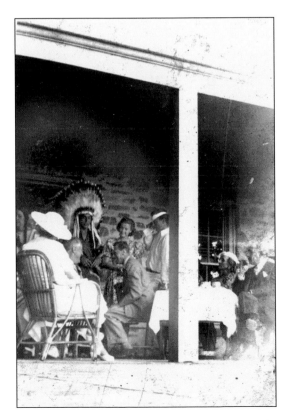

Following the meal, some fine Native American cultural entertainment was provided for the king, queen, and the guests. The porch was partially cleared, and all enjoyed the song and dance. (CMS.)

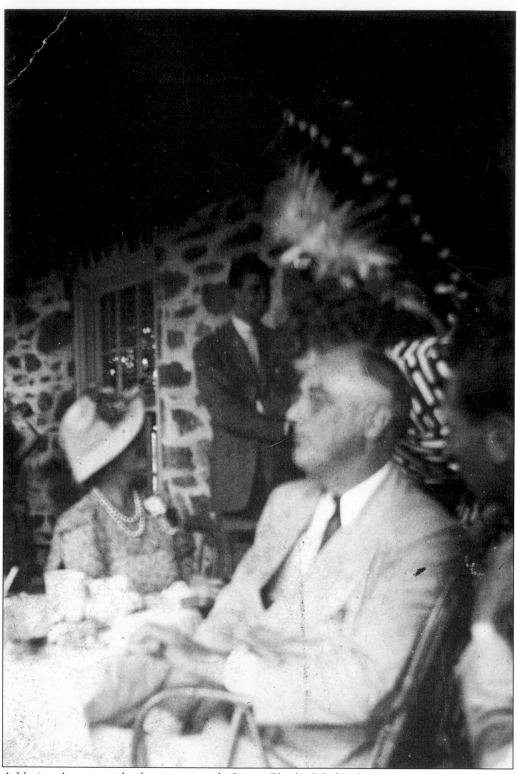

A Native American chief converses with Queen Elizabeth behind Roosevelt. (CMS.)

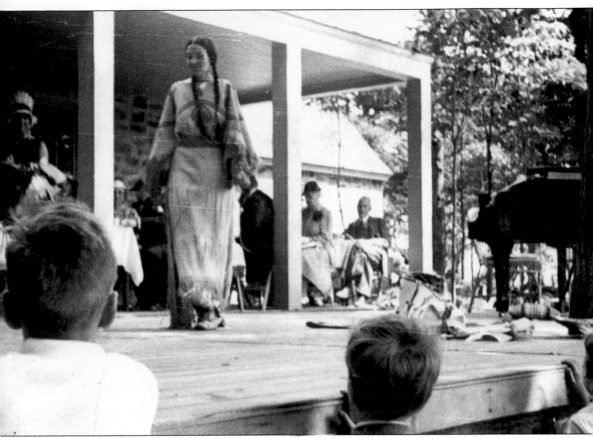

Princess Te-Ata provided some song. Two young Johannesen boys are seen by the stage. (CMS.)

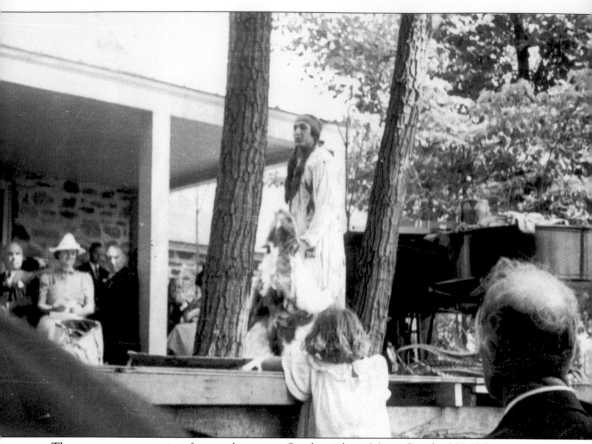

There was rapt attention for another song. On the right is Moses Smith. (CMS.)

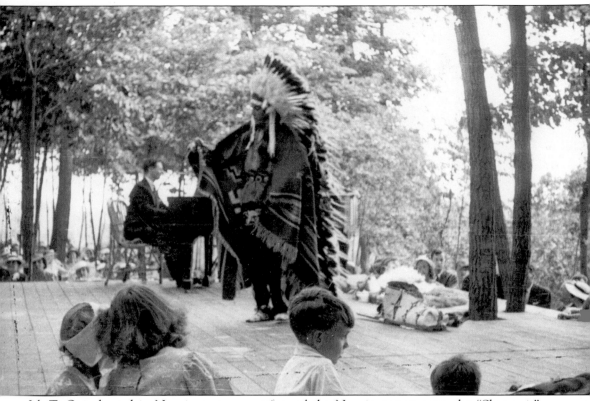

Ish-Ti-Opi, dressed in Navajo costume, performed the Navajo potato song, the "Shanewis" canoe song, the sunrise call (a chant), and others. (CMS.)

Ish-Ti-Opi is seen with a young admirer. (CMS.)

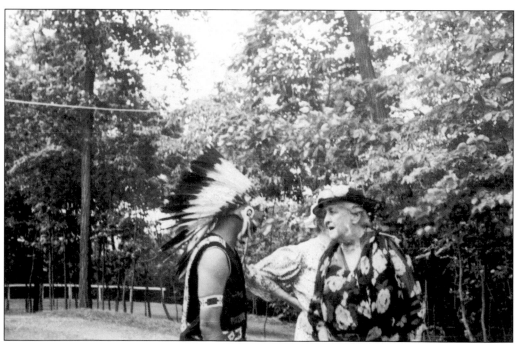

Roosevelt's mother, Sara Roosevelt, is perhaps getting either the first or last word with the chief. Following the picnic and swim at Valkill, the royal family went to Hyde Park and boarded a train heading north to Canada. (CMS.)

Five

FURNITURE

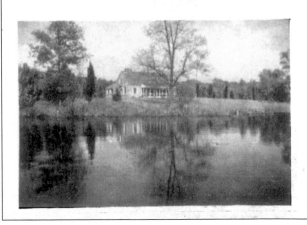

The word Valkill now is synonymous with the cottage industry of crafts developed and owned by Nancy Cook, Marion Dickerman, Eleanor Roosevelt, and Carolyn O'Day. The Valkill Industries furniture factory lasted from 1926 to 1936. This is a front cover from a sales catalog. (NPS.)

Val-Kill Shop

AT THE Val-Kill Shop in Hyde Park, Miss Nancy Cook started early this winter on a new enterprise in which Mrs. Daniel O'Day, Miss Marion Dickerman and Mrs. Franklin D. Roosevelt are also interested.

For a long time the fact has been brought home to many of us, who are fond of old furniture, that authentic early American pieces are becoming more and more difficult to secure. Some of us have a few pieces which we would like to have surrounded by others that are in keeping and so the Val-Kill Shop was started with the idea of making reproductions of those in the Metropolitan Museum or in other good collections. At present we are making only early American 17th century furniture but we could reproduce pieces from any other period in which our customers might be interested.

Our object is to give our furniture the care which was given by the early cabinet makers so that the workmanship and the finish may show some of the charm which those early pieces acquired because their makers really loved the work which they did.

We are indebted for encouragement, advice, and aid in the planning and starting of our shop to Mr. Charles Cornelius of the Metropolitan Museum; Mr. Morris Schwartz, one of the foremost authorities on early American furniture in this country; and Mr. Henry Toombs, architect, who is helping with some of our designs.

This is the inside of the brochure. The pieces of furniture produced were reproductions of Early American forms found in museums. Some pieces were modified in size or utility. Valkill

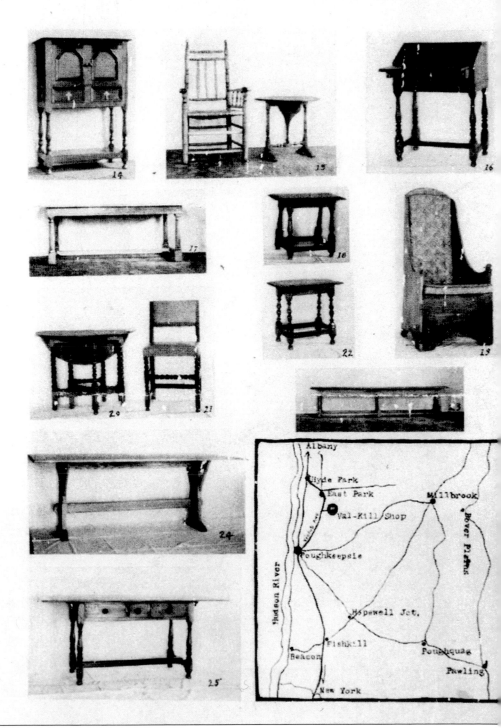

Industries was started with the desire of Eleanor and the women to employ local farm boys so that they would stay in the small town and not migrate to the cities. (NPS.)

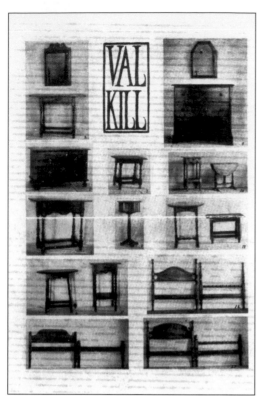

This is the back cover of the brochure. Representative pieces are highly prized by collectors. (NPS.)

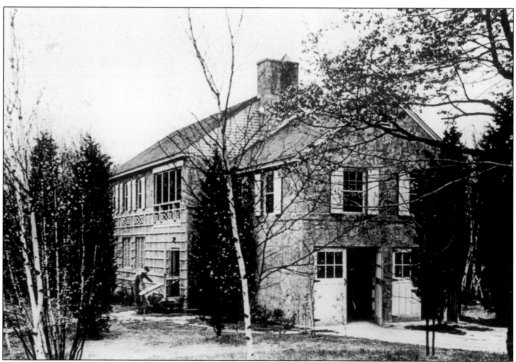

The original Valkill Industries furniture factory building, located northwest from the stone cottage and built in 1926, is seen here. (NPS.)

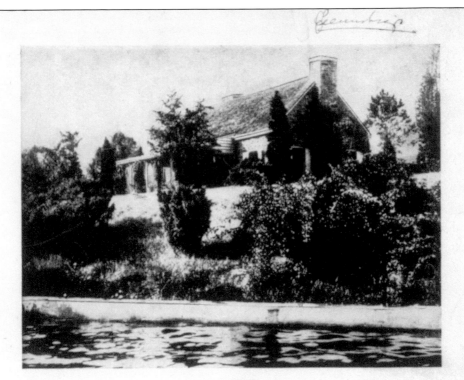

VAL-KILL

Hyde Park, Dutchess Co.
New York

Buying Heirlooms
for Your Great-Great-Grandchild

There is something fascinating in the idea of preserving not only our name, but some tradition of what manner of person we were, in the memories of our Great-Great-Grandchildren a hundred years and more from now. Few of us can hope to do things noteworthy enough to be remembered long after our contemporaries are forgotten, but there is still one way left.

If we acquire something so beautiful, in the best sense of the word, that it will be preserved for its own sake and so sturdy in its construction as to defy time, we may be sure that it will be handed down from generation to generation with some clinging tradition as to who we were and what we did.

Val-Kill Furniture is built, not "manufactured," as the old master craftsmen of the days of Sheraton and Chippendale built; mortise and tenon, perfect fitting joints.

Most modern furniture will hardly survive a decade of even careful usage. They will never become the heirlooms of the future.

We will be glad to show just how Val-Kill Furniture is made and why; when you secure a piece with the Val-Kill "Hall-Mark" you have an heirloom by which your Great-Great-Grandchildren will still remember you.

MRS. FRANKLIN D. ROOSEVELT

FINE HANDMADE FURNITURE
by
The Hyde Park Village Craftsmen

New York Show Rooms
Madison Ave.—Room 704
New York City

Another sales brochure pictured the bucolic scene of the Valkill stone cottage. (NPS.)

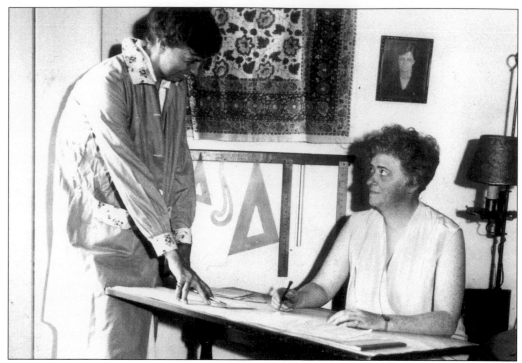

As the brochure states, the ladies visited museums to take measurements of furniture that they would produce. Nancy Cook, seen here with Eleanor, made detailed drawings of each design. (NPS.)

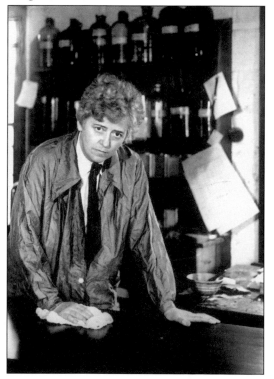

This is a well-known picture of Nancy Cook in the finishing room of the woodshop. Nancy was the prime mover of Valkill Industries. She had the greatest interest in furniture making and supervised the business. She had always liked working with wood. She and Marion Dickerman graduated from Syracuse University. During World War I, the women went to England, where they both worked in a hospital. Nancy made wooden prosthetic devices for injured servicemen. (FDRL.)

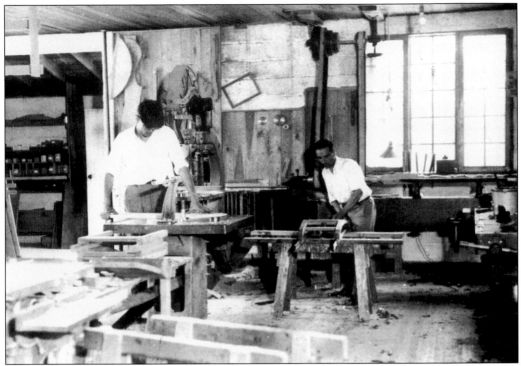

The Valkill Industries furniture shop is seen in action. Frank Landolfa (right) and Karl Johannesen are pictured. Eleanor Roosevelt worked mostly in public relations for the business, using her famous name to help sales. (NPS.)

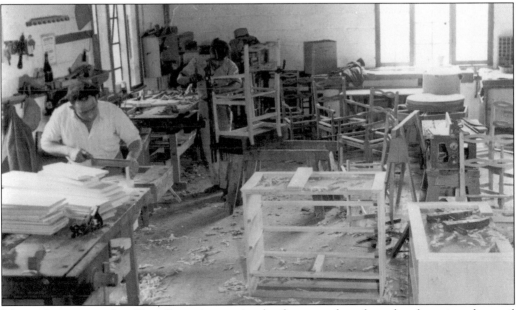

Master furniture maker Otto Berge is seen in the foreground, perhaps hand-cutting dovetail joints for the drawers of a chest. Ribbon-back chairs of Nancy's design are being made as well. The craftsmen used hand production for most of their pieces. They used dovetail and mortise joints, as well as wooden dowels and pegs. Solid wood was used for all furniture. (FDRL.)

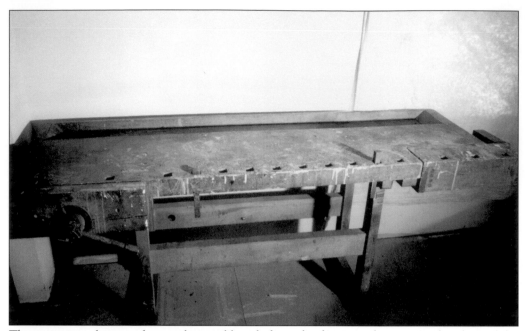

This view is a closeup of a wooden workbench from the furniture factory. At the close of the factory, this was given to Clifford Smith and now is in the author's collection. Its manufacturer is Hammacher-Schlemmer in New York City. (RC.)

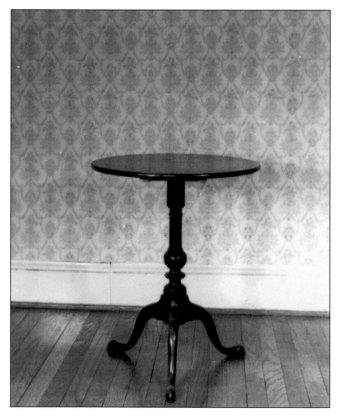

Pictured is an example of a large candle stand in the Chippendale style. Most products of Valkill Industries were Early American reproductions. The ladies visited and consulted with several museums and made drawings of pieces they wished to reproduce. (FDRL.)

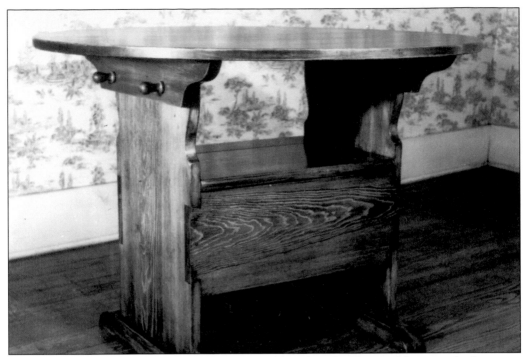

Seen here is a pine Early American tilting-top table or bench. This would serve a dual purpose in that it was a table with a top that tilts up to form a seat with a tall back. (FDRL.)

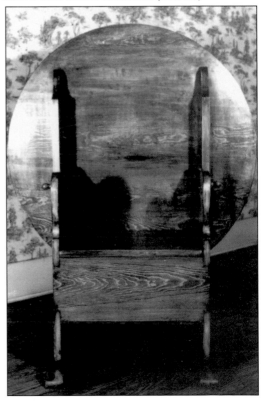

This photograph is of the same piece in the seat configuration. In early America, this would be placed close to the home fireplace, and the tall and broad back would gather the fire's radiant heat. (FDRL.)

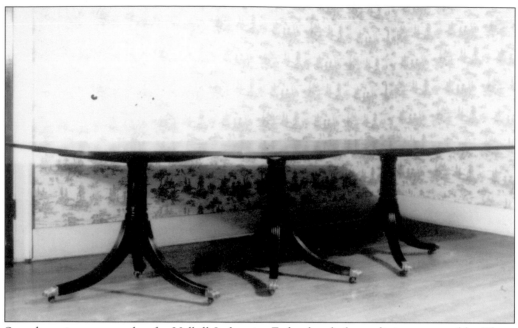

Seen here is an example of a Valkill Industries Federal-style large dining room table. These Valkill furniture photographs were taken during the time of the manufacture of each piece. (FDRL.)

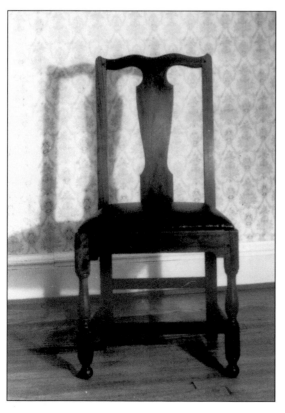

Seen here is a single-side chair. A set of these would accommodate perhaps 10 to 12 people at the dining table. (FDRL.)

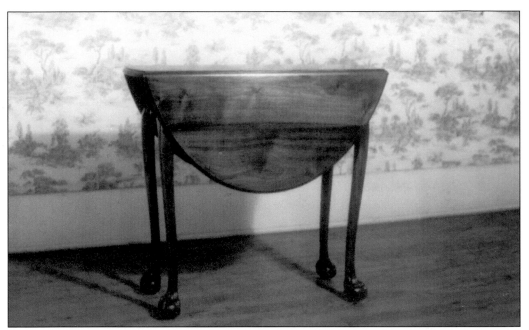

Seen is a fine example of a Chippendale-style, ball-and-claw-foot drop-leaf table. The sides would lift up and be supported by an arm on each side to produce a round table. Folded as shown, it would be pushed closer to the wall to take less floor space. (FDRL.)

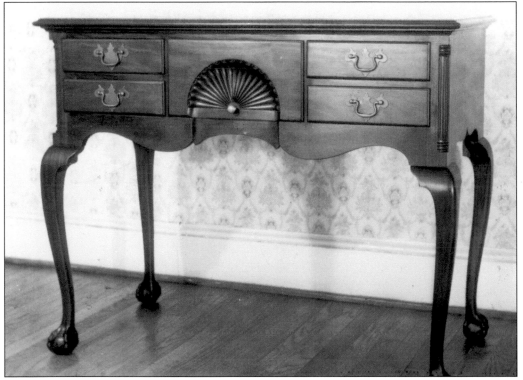

Here is another fine example of a Chippendale-style ball-and-claw-foot sideboard. It has two drawers on either side of the scallop-shell, hand-carved larger center drawer. (FDRL.)

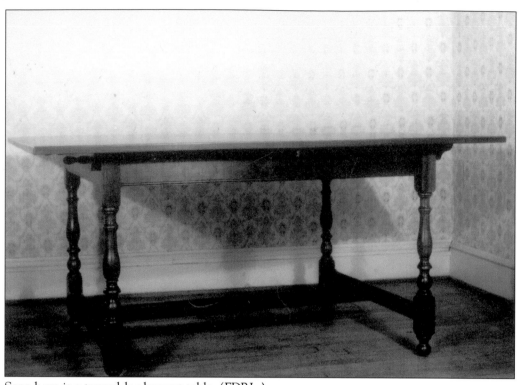

Seen here is a turned-leg harvest table. (FDRL.)

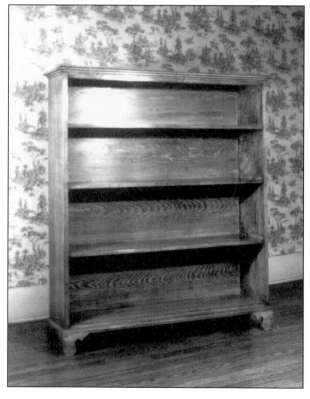

This photograph shows a pine four-shelf bookstand. (FDRL.)

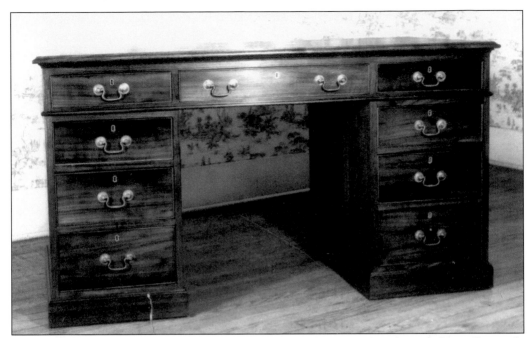

Valkill Industries made several different styles of desks. The one pictured is a modern office-style desk with drawers. Eleanor Roosevelt had a similar desk in her cottage. Other desks were slant front in the Early American style, with various pigeon holes and turned legs. Some modern desks had built-in bookshelves on the front. (FDRL.)

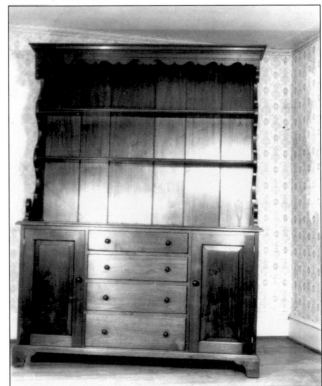

Seen here is a two-part hutch, which was probably used in dining rooms, kitchens, or pantries. Drawers and doors varied on the hutch bottoms. Valkill Industries even produced some with small cabinet doors on the top portion. (FDRL.)

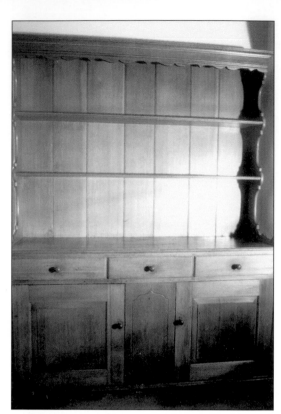

Note the bottom drawer variation of this hutch. This was one of two hutches that were auctioned at Valkill in 1970 by John Roosevelt. (RC.)

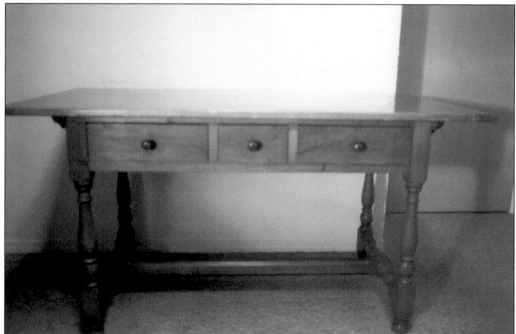

Seen here is a three-drawer, maple turned-leg harvest table. It is 29.5 inches high, and its top is 28 by 55 inches. Valkill furniture was almost always stamped with either of two marks. On this piece, the middle drawer's top edge was stamped with "boxed" Valkill. (RC.)

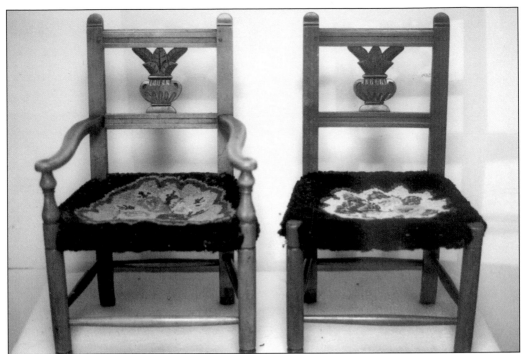

Seen here is a pair of maple chairs sized for children. They are 23.5 inches high, with a seat height of 11 inches. The original woven rush seats have been replaced by Clifford Smith with hooked burlap floral patterns. (RC.)

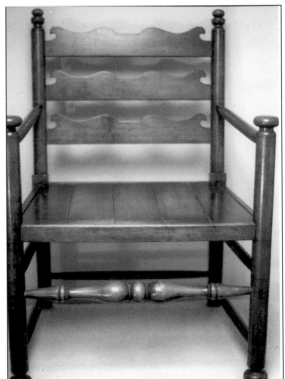

This piece is a cherry pilgrim-style plank-seat chair. This chair has the Valkill trademark stamp, but it also has a signature stamp of Eleanor Roosevelt on the back of the top slat. (RC.)

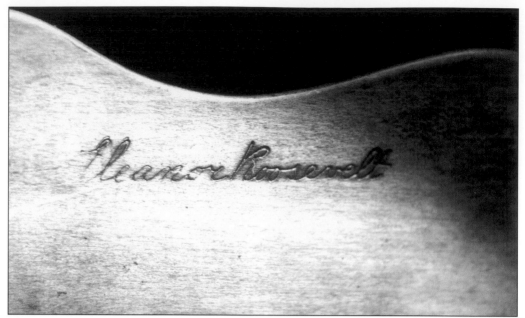

Eleanor Roosevelt's signature stamp is seen on the back of the cherry chair. Valkill pieces with this stamp are reportedly the most rare and prized by collectors. It is believed that furniture with this stamp was Eleanor's own furniture or was ordered directly by her as special gifts to people she held in unique regard. (RC.)

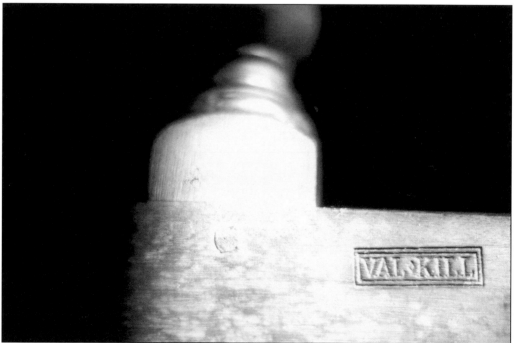

Seen here is one of two Valkill trademark stamps. This is the "boxed" stamp with a diamond between Val and Kill. It is believed that this is the second stamp used. An earlier stamp with simple block-lettered Valkill is also found on furniture. All stamps are branded into the wood with hot irons before finishing. (RC.)

Seen is a mirror with a walnut frame. It is 28.5 inches high and 17 inches wide. (RC.)

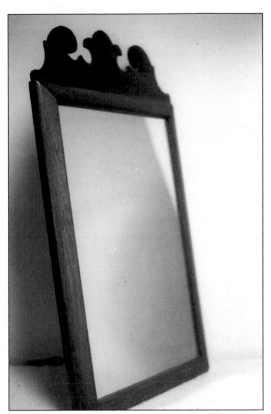

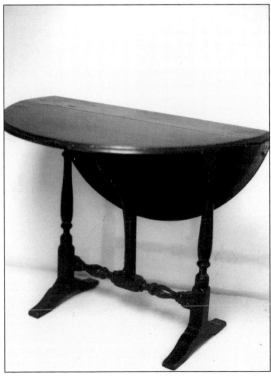

This small walnut drop-leaf table is of a different style than the earlier example. It is 22 inches high, and the top is 26 inches in diameter. (RC.)

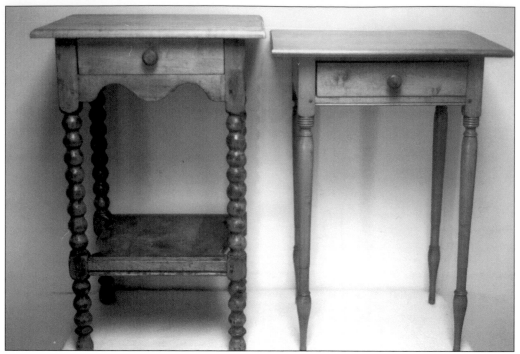

Two examples of bedside tables are seen here. Both are single-drawer tables that are made of maple. Both tops are 16 by 18.75 inches. The left table is 28 inches high, and the right table is 26.5 inches high. (RC.)

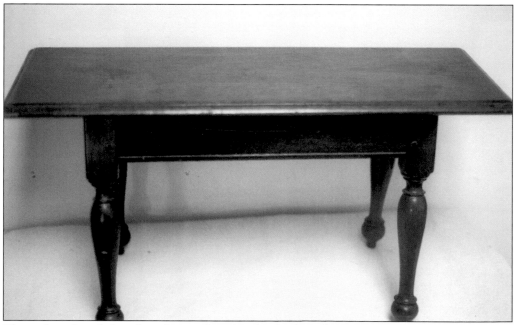

This walnut fireside bench or footstool is 15 inches high, and its top measures 28 by 10.5 inches. Another example of this is located in the New York State Museum in Albany. (RC.)

Eleanor Roosevelt and Nancy Cook (far right) view furniture with Frank Landolfa (far left) and Otto Berge outside of the factory. (NPS.)

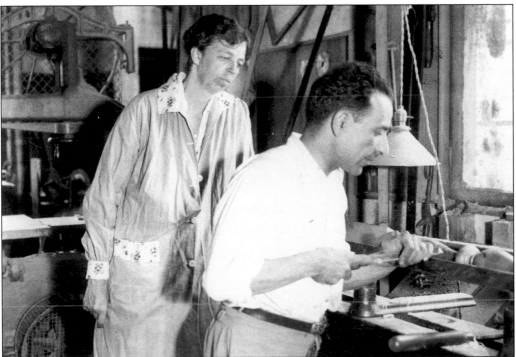

Eleanor Roosevelt learns the art of lathe-turning wood from Frank Landolfa. (NPS.)

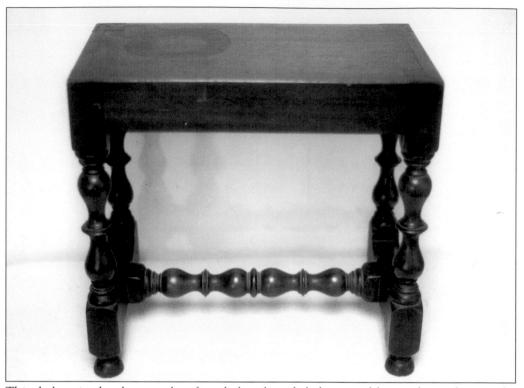

This dark-stained walnut stool or fireside bench with lathe-turned legs and stretchers in the Edwardian style is 17 inches tall, and its top is 18 by 10.5 inches. (RC.)

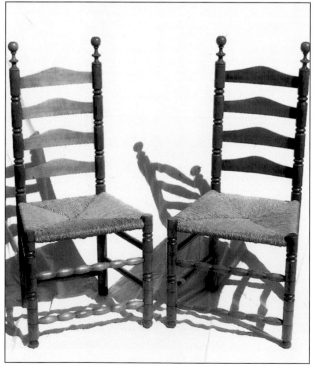

Seen here are two, of a set of four, maple ladder backs with rush seats. All furniture was constructed in the Early American tradition. (Kathy Gaffney.)

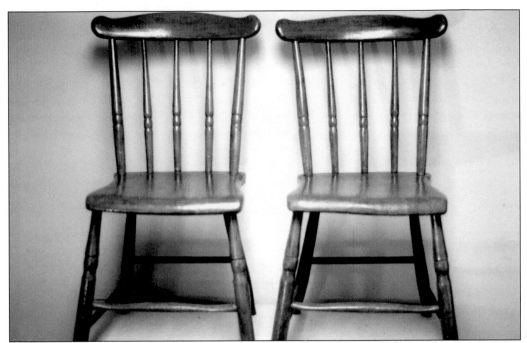

These two rather primitive slab-seat chairs are purportedly to have come from the tearoom. This was a sales room in a building on Violet Avenue just south of the Valkill driveway at the intersection of Creek Road. It currently houses a restaurant. This building was also the site where Valkill Industries had some looms used by Nellie Johannesen and other local women to weave cloth and make hooked and braided rugs. (RC.)

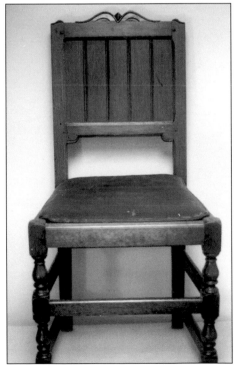

This walnut Edwardian-style, panel-back plank-seat chair has its original leather cushion. Other Valkill panel-back chairs have no air space between the seat and back. The use of solid wood and the finish on all Valkill furniture make it stand out. Cook had developed her own secret finishing process, which would have included staining with multiple layers of varnish. Each coat was hand-rubbed, and it has a smooth non-glaring but warm texture to it. (RC.)

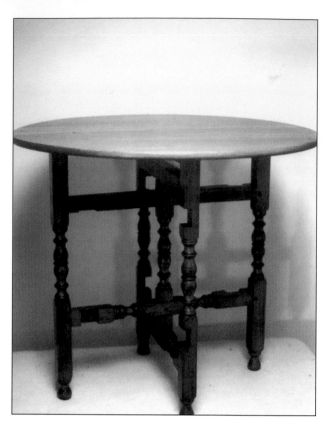

Some Valkill furniture designs differed from Early American designs. They were modified to match the then-modern homes or apartments. Sizes and dimensions were altered. This walnut table, which is 26 inches high and has a top that is 29 inches wide, is listed in the sale catalog as a tilt-top table. The legs fold in on each other, and the top is hinged to fold down. When collapsed, it is about four inches wide and can be stored behind a door or in a closet. (RC.)

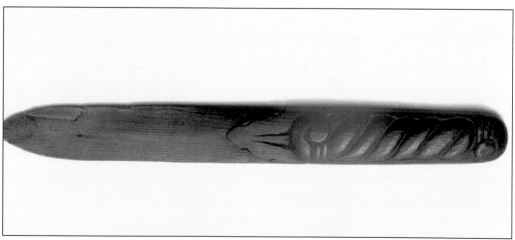

This hand-carved walnut letter opener measures 12 by 1.25 inches. One of the crafts learned by some of the workers was woodcarving. This letter opener would have been easily made by an apprentice woodworker. One of the goals of the Valkill Industries was to employ farm boys so they would not go to work in larger cities. Another goal was to teach woodworking crafts to people. A young Clifford Smith was taught woodcarving at Valkill, and he, in turn, taught the author. Although Valkill Industries was a failure as a business venture, there was some success. (RC.)

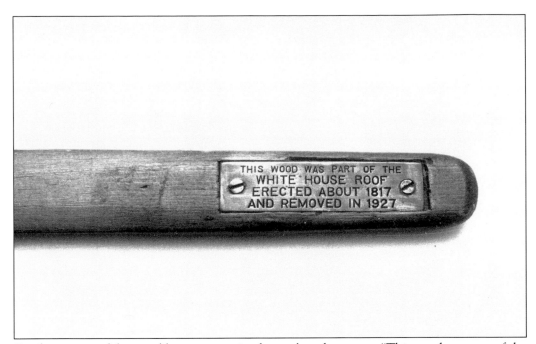

On the reverse of the wood letter opener is a brass plate that states, "This wood was part of the White House roof erected about 1817, and removed in 1927." Valkill Industries obtained some of this roof wood and marketed it as a useful souvenir. (RC.)

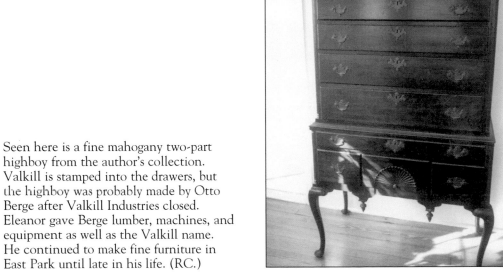

Seen here is a fine mahogany two-part highboy from the author's collection. Valkill is stamped into the drawers, but the highboy was probably made by Otto Berge after Valkill Industries closed. Eleanor gave Berge lumber, machines, and equipment as well as the Valkill name. He continued to make fine furniture in East Park until late in his life. (RC.)

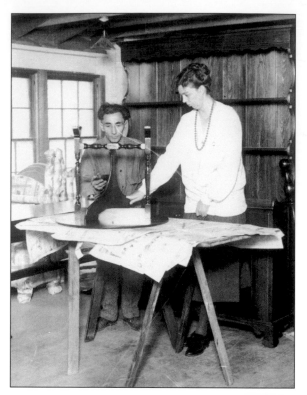

Frank Landolfa is pictured with Eleanor Roosevelt. Landolfa was an Italian immigrant and a master furniture maker at Valkill Industries. He and Otto Berge were hired for their furniture-building mastery and to teach local people the woodworking art. After the close of Valkill, Landolfa continued to make furniture and repairs in Poughkeepsie until his death. (RC.)

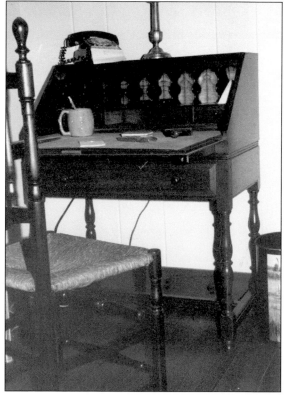

The Valkill Industries chair, the folding front desk, and the lamp seen here are currently on display at Eleanor's home at the Valkill National Historic Site. The National Park Service has obtained many of the original furnishings of her home. Clifford and Arthur Smith both worked part time at the furniture factory. Clifford was sent to an art school in New York City, where he learned drawing and design. At Valkill, he also learned woodcarving and rug hooking and braiding. (RC.)

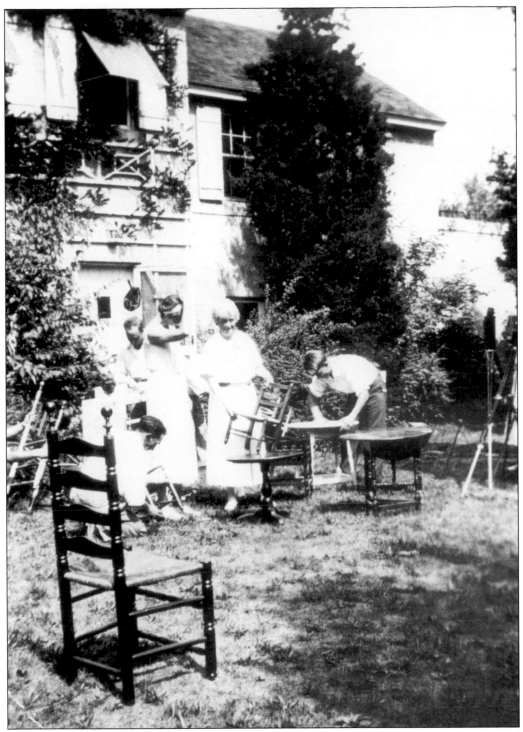

Seen here is a view of more furniture outside of the factory before being crated and shipped. (NPS.)

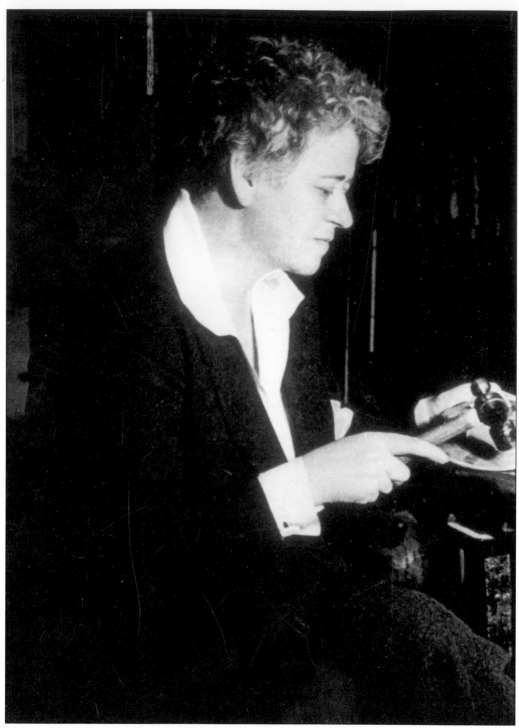

The quality of items produced at the factory surely is a tribute to the passion that Nancy Cook had for the furniture business. Not only did she oversee work at Valkill, but during the New Deal changes of America at the time, she was also asked to develop a similar woodshop and crafts industry at a planned community in Arthurdale, West Virginia.

Six

PEWTER

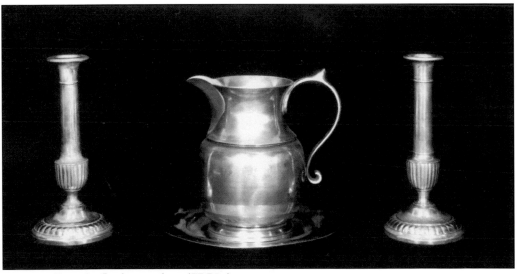

Two candlesticks flank a pitcher. (FDRL.)

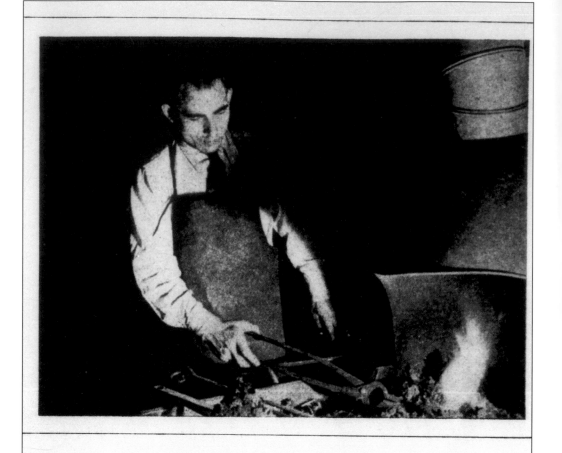

THE FORGE

VAL-KILL LANE
HYDE PARK
DUTCHESS COUNTY
NEW YORK

Started in 1934, the forge or pewter shop was also developed as part of Valkill Industries. It was operated by Otto Berge's brother Arnold. He produced mostly items of pewter but dabbled some in other metals. (NPS.)

THE FORGE

VAL-KILL LANE
HYDE PARK · DUTCHESS CO · N. Y

THE Forge was established in the village of Hyde Park by Mrs. Franklin D. Roosevelt with the idea of giving employment to a few young men and to renew interest in the age old art of metal craft.

Beautiful articles of pewter, brass, copper and iron are fashioned by hand. All pieces are made out of the very best of materials, they are heavy and have the rich texture which gave such charm to many of the old pieces. Each article bears the Val-Kill trade mark.

Let Us Do Your Gift Shopping For You!

Just mail us your card and the address of the person you wish to receive the gift and we will pack the gift beautifully and mail it directly from the Forge.

Each month we will send you a bill covering the gifts ordered by you.

Samples of these articles are on exhibition at 331 Madison Avenue, at 43rd Street, Room 704, New York City

This is the back cover of the brochure. The forge started in a room of the furniture factory but went into its own building, which later became the playhouse at its close. (NPS.)

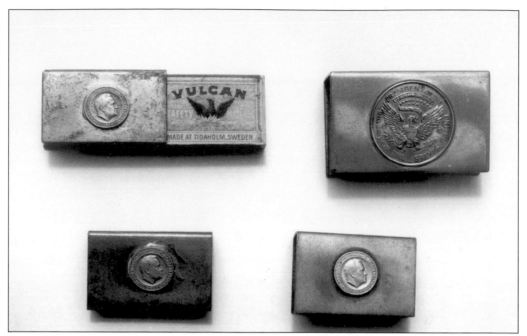

Examples of matchbox covers are seen here. Two sizes were made, with various medallions applied to each. Many of these were produced and then sold for either 65¢ or 80¢, depending on size. Franklin Roosevelt gave 175 matchbox covers as gifts to White House staff members for Christmas in 1935. (RC.)

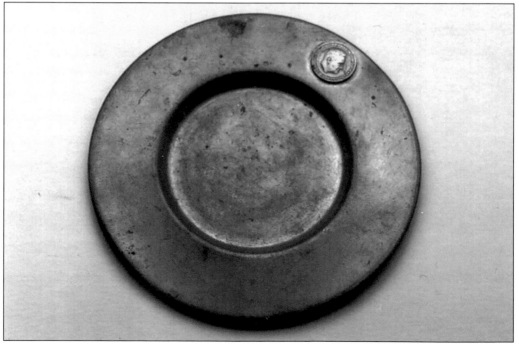

On this small pewter dish is a Franklin Roosevelt bust coin. The coin reads, "FDR Hyde Park, New York." Almost all forge items were stamped with a trademark on the bottom or underside, not to be readily seen. (KG)

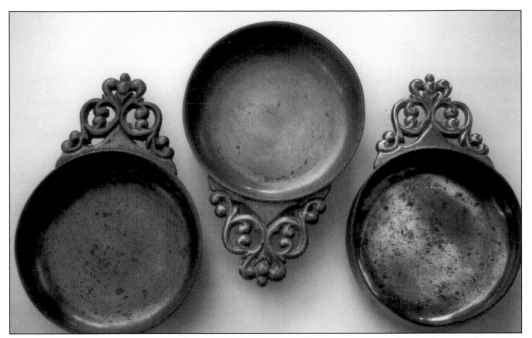

Seen is a set of small single-handle pewter porringers. The openings are four inches in diameter. The handles were formed in molds of bits and scraps of pewter and were then attached to the round dish using heat. (RC.)

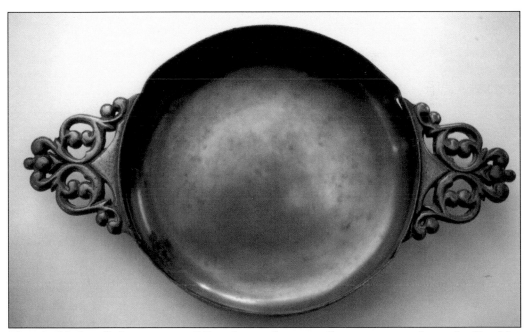

This double-handled porringer is 5.5 inches in diameter. Some porringers have the Franklin Delano Roosevelt bust coin incised in the handle. (RC.)

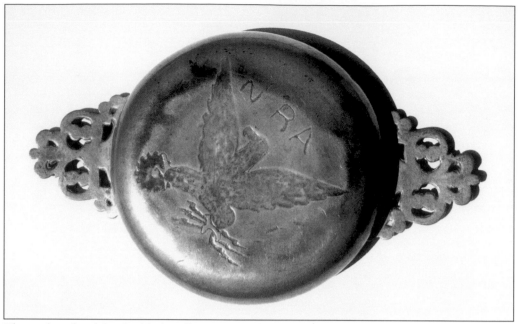

The underside of the double-handle porringer shows perhaps a unique variation. The National Recovery Administration spread eagle is inscribed in the pewter. (RC.)

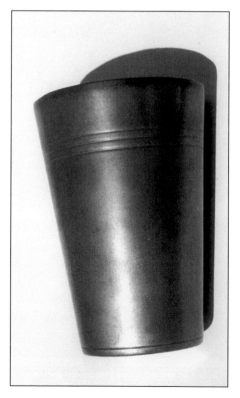

This four-inch pewter cup held approximately six ounces. The forge made and sold many different items, including vases, inkwells, creamer and sugar sets, salt and pepper shakers, bottle openers, cheese knives, pitchers, plates, candlesticks, and many other useful items. (RC.)

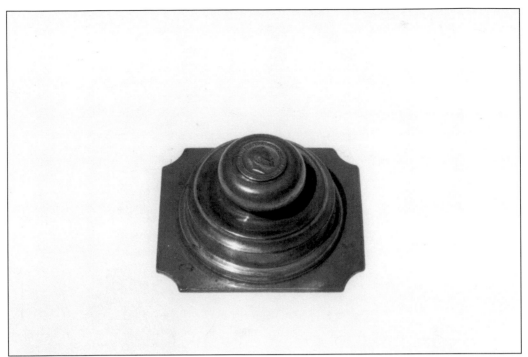

A pewter paperweight with a Roosevelt coin is seen here. For Christmas in 1938, Roosevelt ordered 200 of these at a $1.25 each to give to the office staff at the White House as gifts. (RC.)

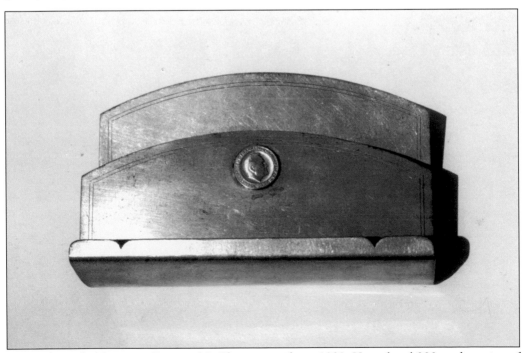

Pewter letter holders were Roosevelt's Christmas gifts in 1939. He ordered 200 at the price of $1.25 each. (RC.)

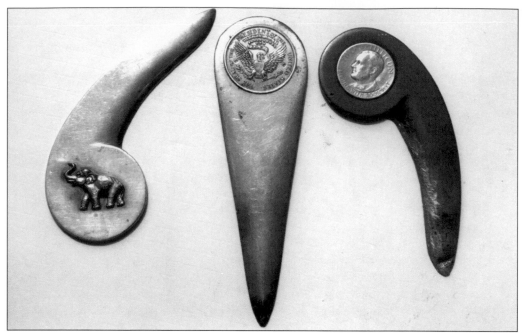

Many types of coins and brass figures were decorative additions to the various pewter letter openers made at Valkill. One wonders if the elephant was marketed for Republicans. The middle letter opener is the same as those that were given as Christmas gifts in 1936. At a cost of $3 each, Roosevelt sent 200 of them out to his staff members. (RC.)

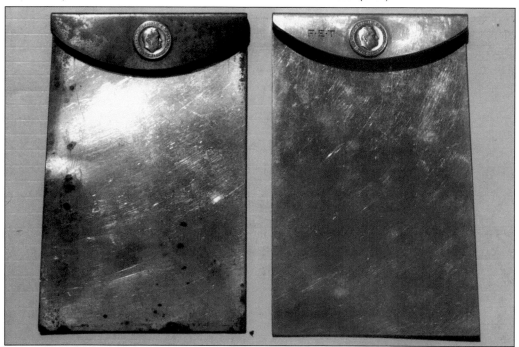

Roosevelt ordered 175 pewter paper pad holders for Christmas gifts in 1937. They cost $2.25 each. As stamped, the one on the right was given by Anna Eleanor Roosevelt on January 6, 1938, to FET. (RC.)

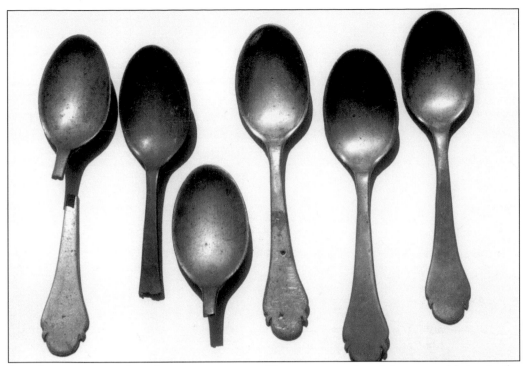

Seen here are examples of pewter teaspoons. These were produced from a mold, in similar fashion as the porringer handles. (RC.)

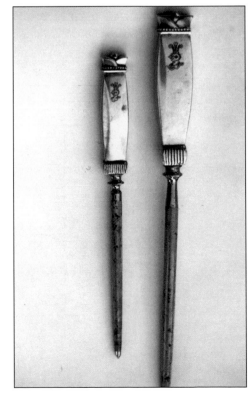

This is the only known pair of pewter-handle knife sharpeners made at Valkill by Arnold Berge. They were commissioned by Franklin Roosevelt and given to Eleanor as a Christmas present during the 1930s. These sold at Christies in February 2001. Note the Roosevelt family crest on the handles. (RC.)

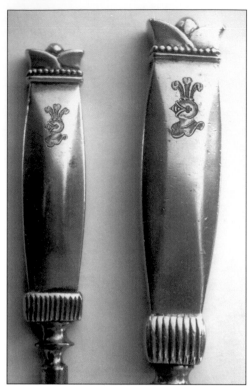

Note the detail of the knife-sharpener handles and the intricate Roosevelt crests that were etched in. Handles of the same style, but smaller, were used for cheese knives and bottle openers. (RC.)

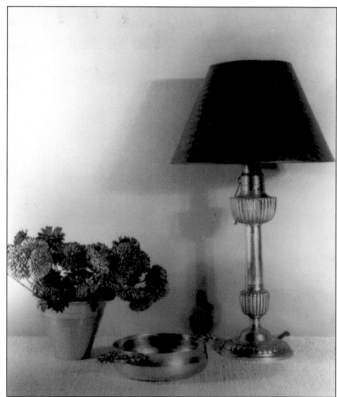

This photograph, taken possibly for a catalog during the time of the forge, shows a vase, double-handled porringer, and lamp. (FDRL.)

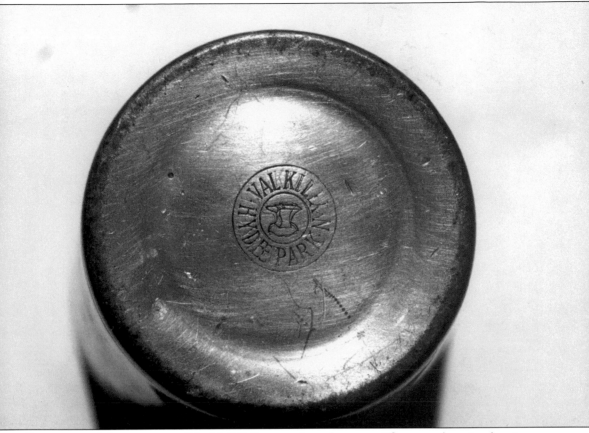

Seen is one of the two types of the Valkill forge trademark stamps. The stamp has circular rings, is inscribed with "Valkill, Hyde Park, New York," and features an anvil in the center. (RC.)

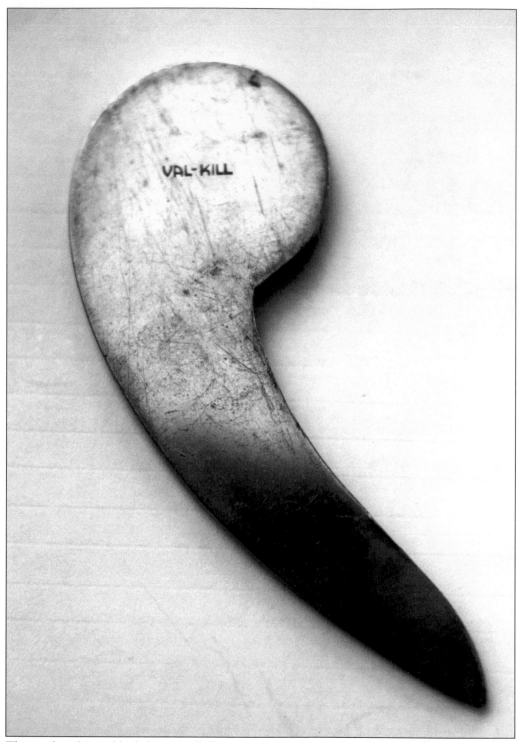

This is the plainer block-letter Valkill stamp. Other stamps found on Valkill pewter include a griffin or Arnold Berge's personal moniker, a. berge, as seen in the photograph on the next page. (RC.)

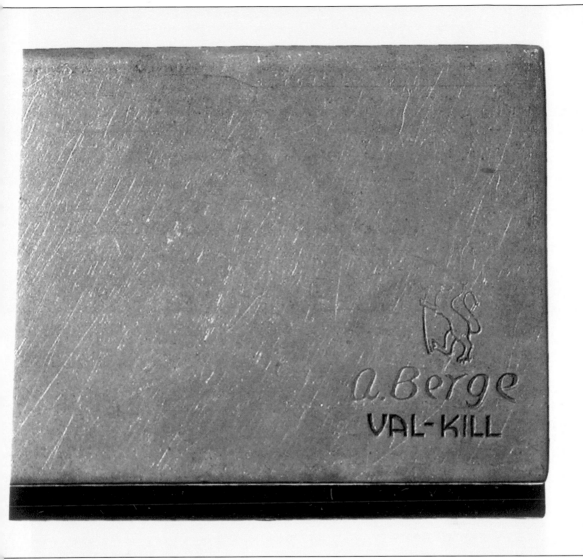

Various stamps are seen here. (KG.)

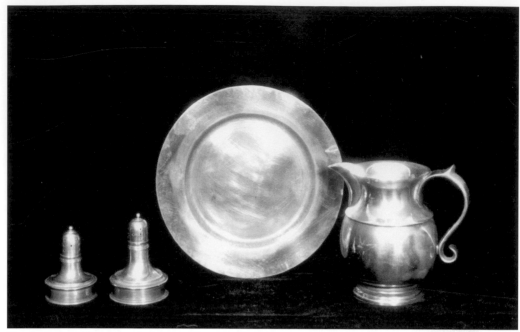

Pewter salt and pepper shakers, a 12-inch plate, and an 8-inch pitcher are seen here. (NPS.)

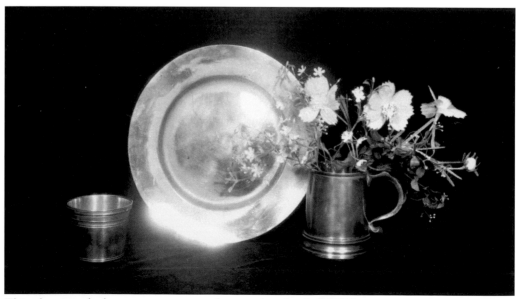

This photograph shows a pewter cup, plate, and tankard. (NPS.)

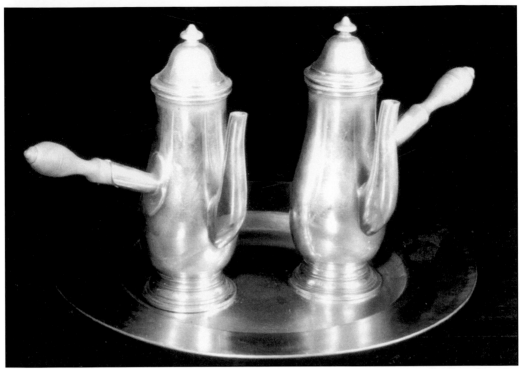

This pewter coffee and creamer set has wooden handles. Eleanor Roosevelt owned and used a set such as this in her home. (NPS.)

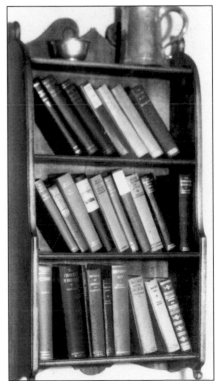

Seen here is a Valkill walnut solid-back hanging bookshelf with a pewter tankard and small bowl. The bookshelf hung in Clifford Smith's home until his passing in 1993. (CMS.)

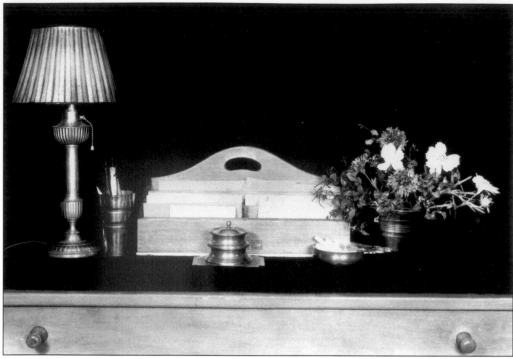

This photograph shows a mixture of Valkill items. Seen are a lamp, cup, inkwell, single-handle porringer, and vase—all made of pewter. The items surround a wooden letterbox holder on a table or dresser. (NPS.)

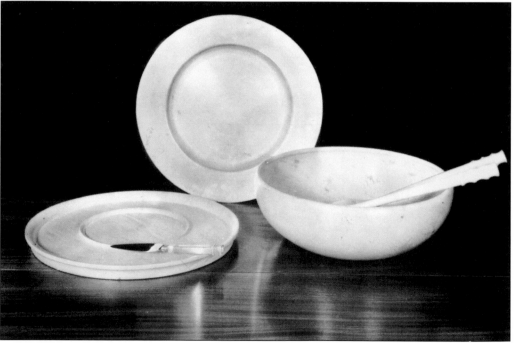

Other items marketed by the forge were a wooden cheese board with a pewter cheese slicer. A wood plate, wood salad bowl, and serving utensils are also seen here. (NPS.)

Seven

PEOPLE

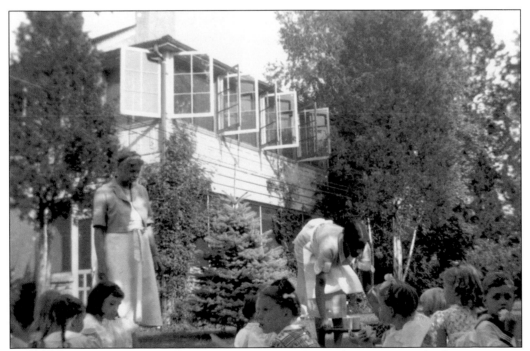

The former Valkill Industries wood shop was converted into Eleanor Roosevelt's living quarters in 1938 after a falling-out between Eleanor, Nancy, and Marion. Nancy and Marion continued to live in the stone cottage. (CMS.)

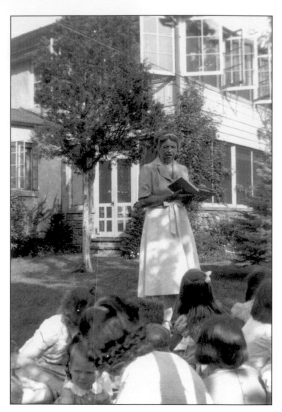

Eleanor Roosevelt had been a teacher at Todd Hunter School for Girls in New York City because of her friendship with Marion, who was the director. She was also involved with many local schools in the Hyde Park area. She would invite children to Valkill and read stories to them on the front lawn. This photograph was taken on August 8, 1940. (CMS.)

Seen here are Nancy Cook and Nellie Johannesen. Nancy was active in Democratic politics. She was also the prime moving force of Valkill Industries. Nellie was a local woman who was a caretaker at Valkill and lived at the teahouse on Violet Avenue. She became involved with the Valkill Industries by producing cloth and fabrics on looms. (CMS.)

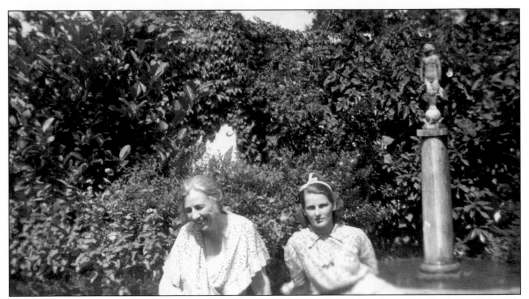

Marion Dickerman and Muriel "Joan" Smith enjoy the garden. Muriel was Clifford Smith's wife and a cook and caretaker at the time. She went on to work at the Hyde Park post office and was active in the Hyde Park Historical Society. (CMS.)

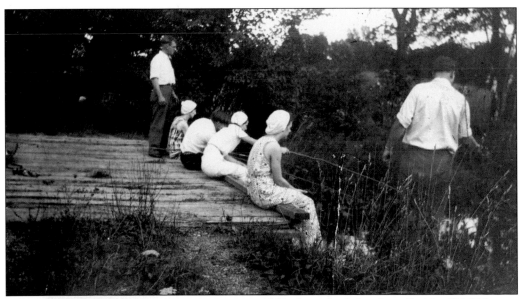

Fishing off of the bridge was a popular pastime. Fifth from the left is Joan Smith. (CMS.)

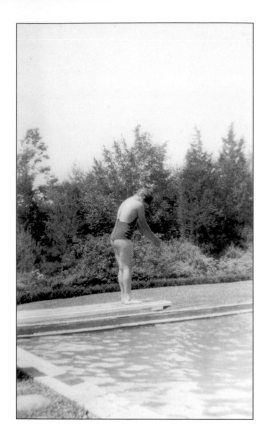

Ann Smith is about to dive in, as seen in this 1940 photograph. Not everyone can swim in the president's pool. (CMS.)

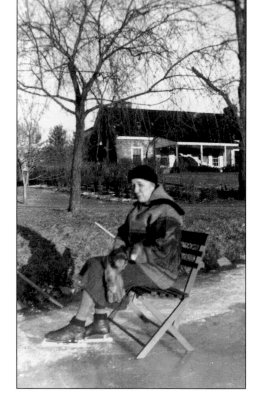

Marion Dickerman rests while ice-skating on the pond dredged from the Fallkill Creek. Marion also became involved with women's Democratic organizations. (CMS.)

Nancy Cook is seen preparing the ice. (CMS.)

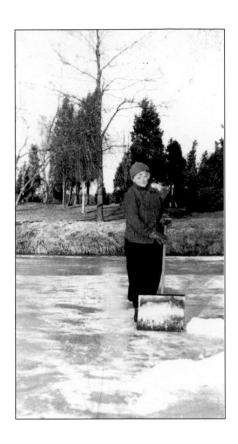

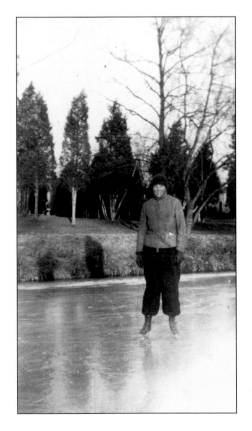

This 1939 view shows Molly Goodwin enjoying the ice. (CMS.)

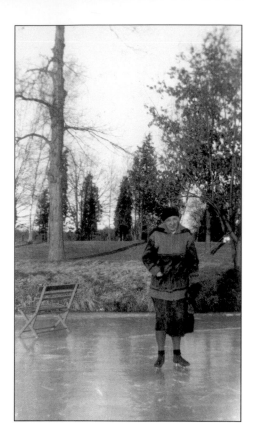

Marion Dickerman stands on her skates. (CMS.)

Valkill was the site of recreation all seasons of the year, wintertime sledding. (CMS.)

The author's grandparents Clifford and Muriel Smith are seen with their daughter Ann at Valkill. The couple was married in 1933, and they worked at the site until 1947. In 1920, when he was 13 years old, Clifford's parents, Moses and Hattie, rented Woodlawns Farm from Franklin Roosevelt. (CMS.)

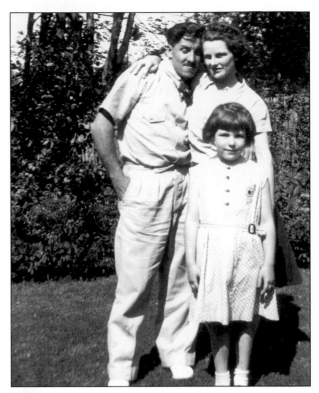

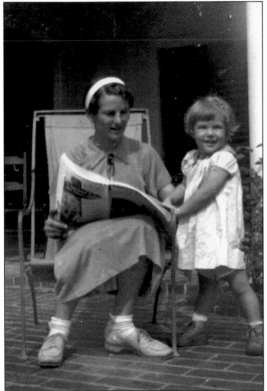

Muriel "Joan" Smith was a cook and caretaker at Valkill. Marion and Nancy were regular in attendance. While she was one-third owner of Valkill, Eleanor—as first lady to the governor of New York and then to the president of the United States—did not get much time at the site. She would send notes through the mail to Joan Smith, advising of dates that she would be there and what menu she would like prepared. Seen here are Joan and her daughter Ann on the back porch off the kitchen. (CMS.)

Ann Smith is seen in this *c.* 1935 photograph. (CMS.)

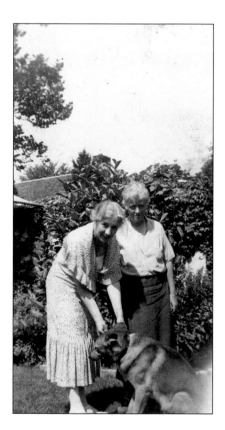

Marion Dickerman, Nancy Cook, and their dog Dean are seen near the loggia. (CMS.)

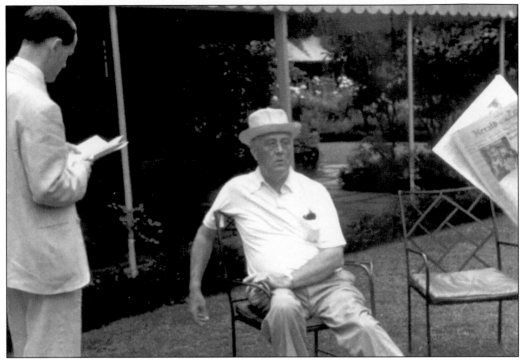

Franklin Roosevelt wears casual attire on a visit at Valkill. (NPS.)

Clifford Smith was the site gardener, landscaper, and part-time worker at Valkill Industries furniture factory and forge. He was proud of his formal gardens. (CMS.)

This photograph, dated May 5, 1938, shows Clifford Smith with a future sister-in-law, Mary Mastin. (CMS.)

Ann Smith is out for a stroll by the pond. (CMS.)

During the age before television and computers, adults and children used their imaginations to occupy themselves. Ann is seen with her baby doll and Dean. (CMS.)

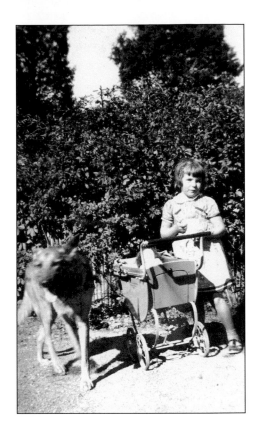

Joan stands by the loggia and flowerbed, which no longer exist at the Valkill site. (CMS.)

In 1938, the furniture factory was converted into living quarters for Eleanor Roosevelt and her secretary Malvena "Tommy" Thompson. There had been a falling-out between Eleanor, Marion, and Nancy. The latter two had continued to live in the stone house until 1947. The upstairs was Eleanor's warm-weather sleeping porch. (CMS.)

Ann Smith is photographed by the west-side stone wall and steps. (CMS.)

Ann Smith (left) and Ruthie Bie stand by the now-dormant furniture factory building in 1939. (CMS.)

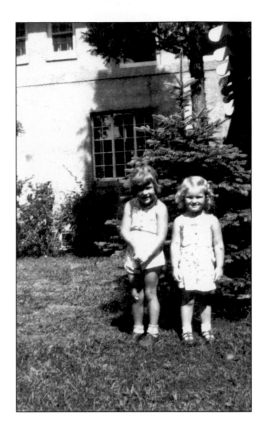

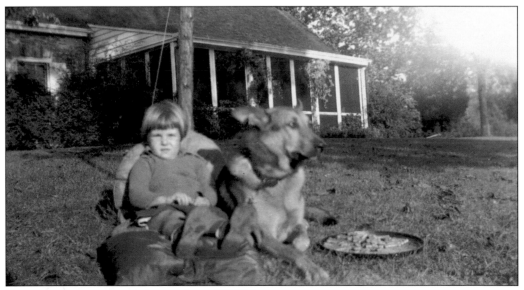

Dean was a close companion to Ann. (CMS.)

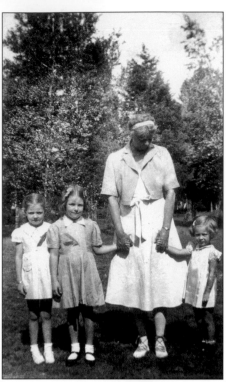

Eleanor Roosevelt poses with three local girls. The girls are, from left to right, Carol Juckett, Ann Smith, and Ruthie Bie. (CMS.)

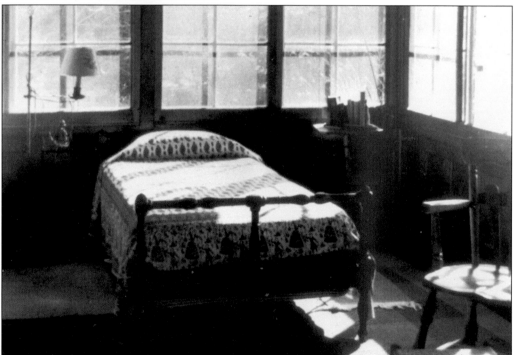

Seen here is Eleanor Roosevelt's bedroom on the sun porch. She would sleep here during the warm weather. Note the Valkill Industries bed and nightstand. This room was in the converted furniture factory building, which was her second home at Valkill. (NPS.)

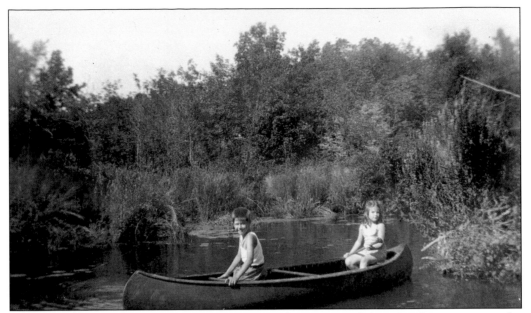

This August 1942 photograph shows young Roy Johannesen and Ann Smith canoeing on the pond. They were children of Valkill Industries workers. (CMS.)

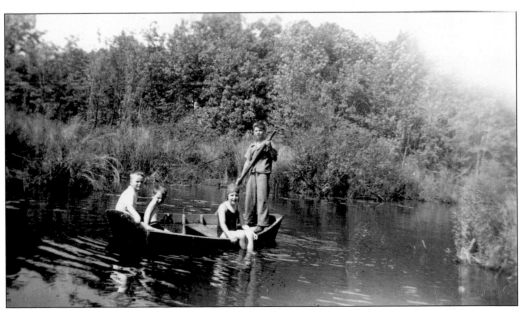

Seen in the rowboat on the pond are, from left to right, Karl Johannesen, Harry Johannesen, Ann Smith, and Roy Johannesen with the oar. The Valkill site was used by the Roosevelts, Nancy Cook, and Marion Dickerman for entertaining as well as living. It was the same for the workers and children of the site as well. (CMS.)

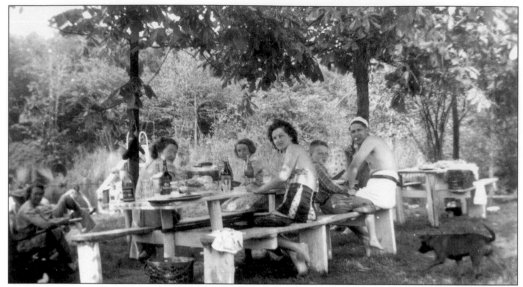

Valkill was a place born of a picnic by the Fallkill stream. The pond and lawn areas continued to be used for picnics for years to come. This June 10, 1943 photograph shows picnic tables set by the water west of Eleanor Roosevelt's home. Seen here are Gladys Brower, Mrs. Mancuso, Joan Smith, Carl Johannesen, and Roy Johannesen. (CMS.)

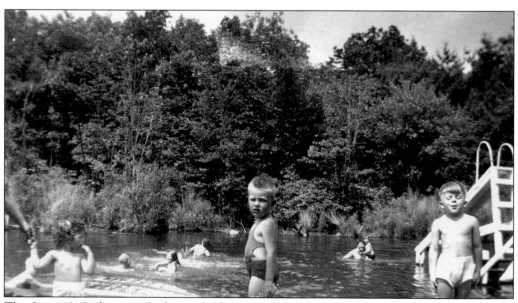

This June 1943 photograph shows children enjoying the pond. On the right is David Smith. Note the slide built into the water. (CMS.)

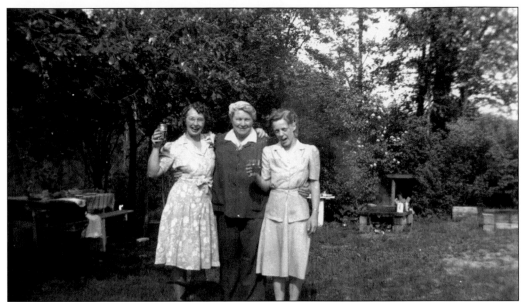

Gladys Brower (left), Nellie Johannesen (center), and Evelyn Johannesen pose in June 1943. (CMS.)

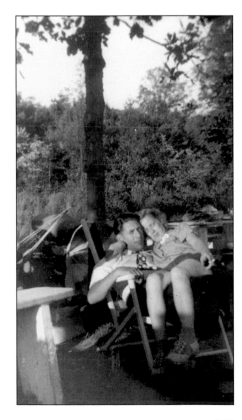

This is a photograph of Roy and Evelyn Johannesen in 1941. (CMS.)

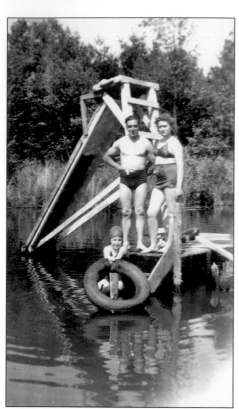

A crude slide and boat dock were built at the Valkill pond. Ann Smith (left), Kenneth Smith, and Betty Meisner pose for this July 1942 photograph. (CMS.)

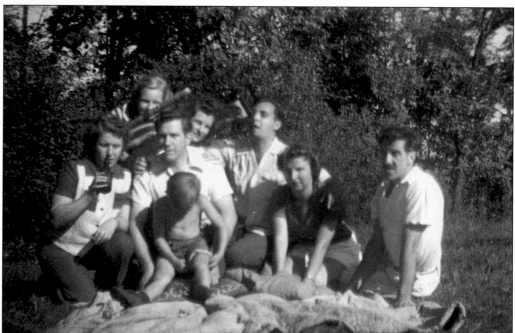

The people seen in this August 1945 photograph are, from left to right, Grace Smith, Ann Smith, Arthur Smith, David Smith (small boy), Joan Smith, Kenneth Smith, Ethel Stimpson, and Clifford Smith. (CMS.)

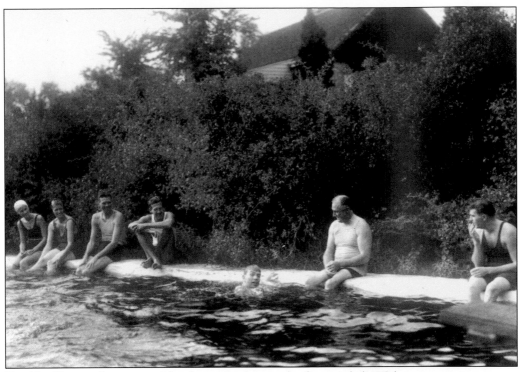

Franklin Roosevelt is seen with other swimmers at the first pool. (NPS.)

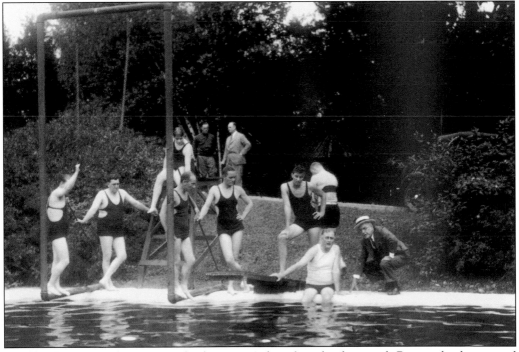

Franklin Roosevelt, his sons, and others are gathered at the first pool. Roosevelt also visited Warm Springs, Georgia, and constructed a home there called the Little White House, where he spent much time in the warm water swimming for muscular therapy. (NPS.)

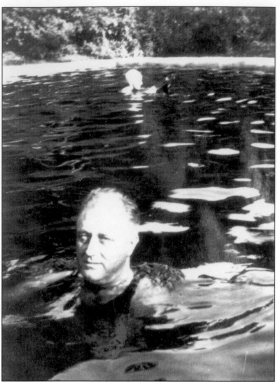

Roosevelt is seen in action. (NPS.)

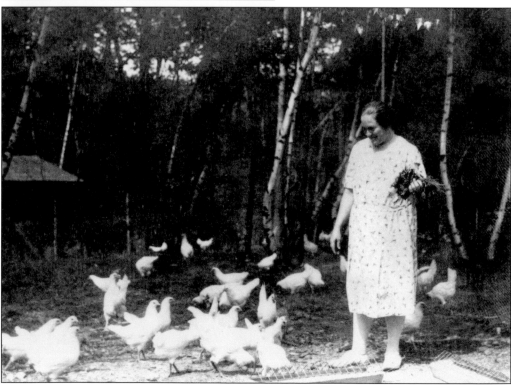

Nellie Johannesen feeds the chickens. (NPS.)

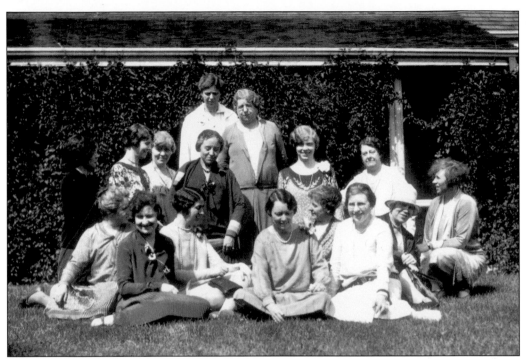

Eleanor Roosevelt stands behind a group of girls from the Todd Hunter School who visited Valkill often. (NPS.)

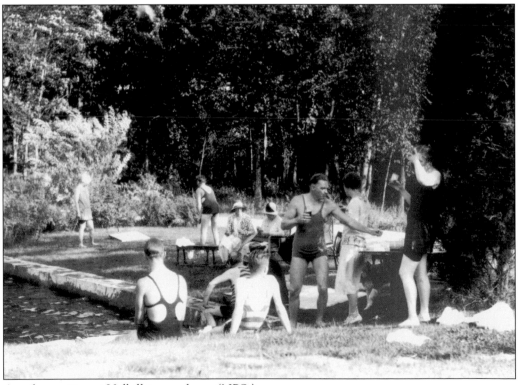

Another outing at Valkill is seen here. (NPS.)

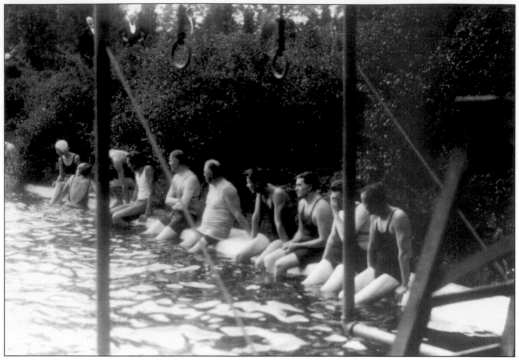

Franklin Roosevelt and his family enjoy the first pool. (NPS.)

Prime minister of England Winston Churchill swims in the second pool. Other people of international and national significance visited the site, including John F. Kennedy, Nikita Kruschev, and Haile Selasse. (NPS.)

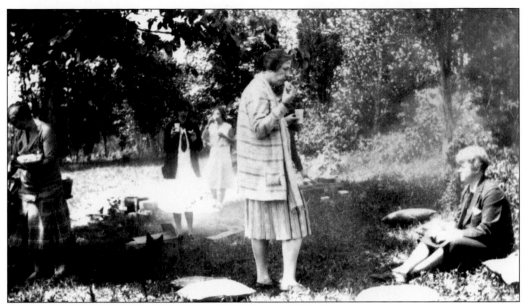

Girls from the Todd Hunter School and Nancy Cook attend a Valkill picnic. (NPS.)

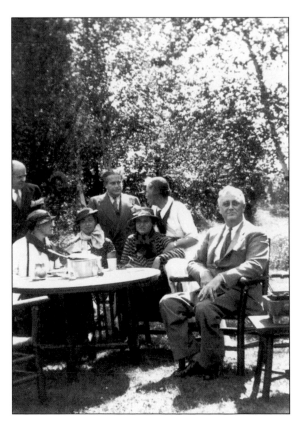

Franklin Roosevelt enjoys a picnic at Valkill. (NPS.)

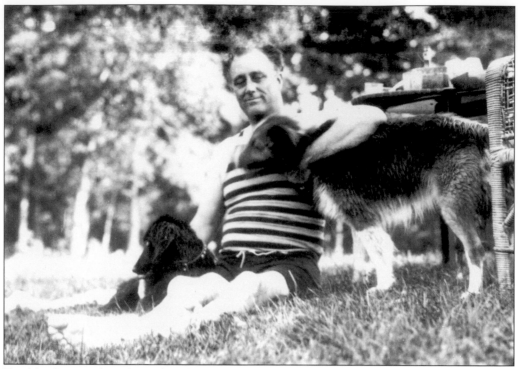

Franklin Roosevelt and two friends appear ready for a swim. (NPS.)

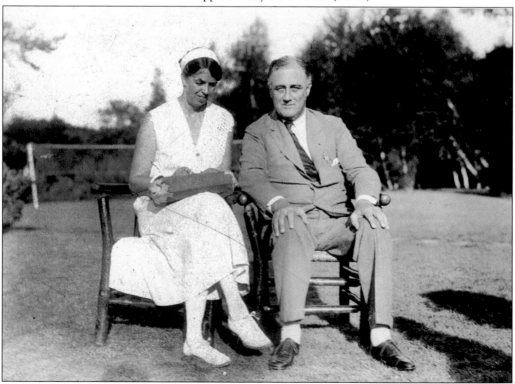

Eleanor and Franklin are seated in front of the badminton court on August 13, 1929. (CMS.)

124

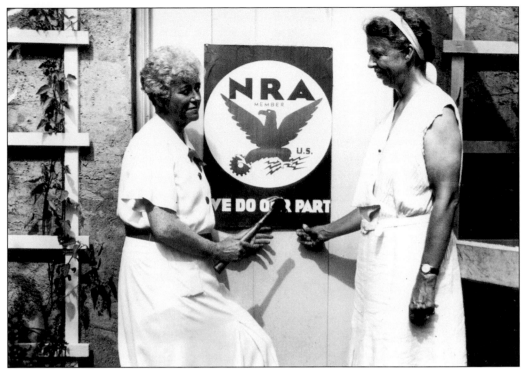

Nancy Cook and Eleanor Roosevelt certainly did more than their part both before and after nailing the poster on the Valkill Industries factory door. (NPS.)

Clifford and young Ann Smith are seen here. (CMS.)

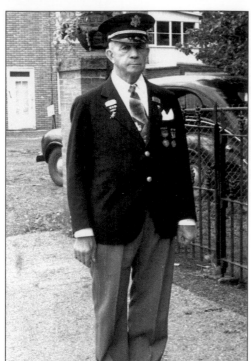

Moses Smith (1872–1959) is pictured here. In 1947, the Smiths left Woodlawns Farm and moved to Market Street in the Hyde Park Village. Smith was a Spanish-American War veteran and was a member of the Hyde Park Fire Department, the Chapel Corners Grange, and the Homecoming Club. He was a member of the Apokeepsing Indian tribe and was a practical political voice in Hyde Park for many years. On Memorial Day 1960, Eleanor Roosevelt dedicated a memorial plaque for Smith. It now hangs in the Hyde Park Town Hall. (CMS.)

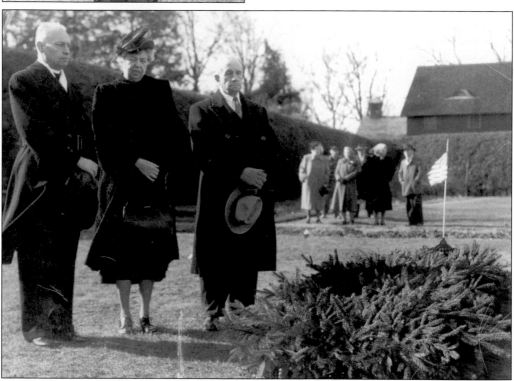

The Reverend Kidd of St. James Episcopal Church in Hyde Park is shown with Eleanor Roosevelt and Moses Smith at a Franklin Roosevelt memorial service in the rose garden at the Roosevelt home site. (John Golden.)

This is the original wooden sign that marked the driveway on Violet Avenue in Hyde Park. (RC.)

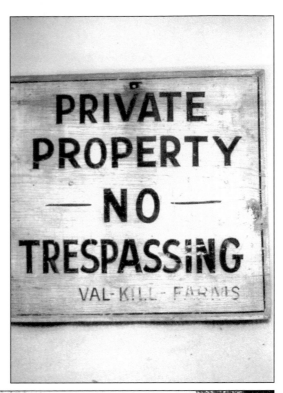

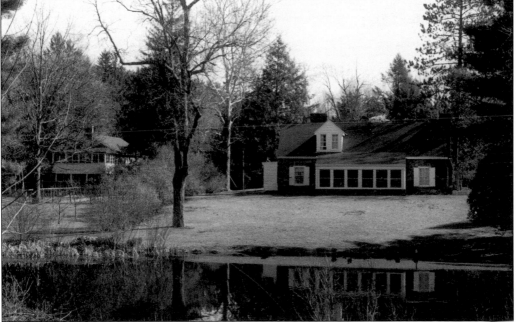

John Roosevelt owned Valkill after Eleanor Roosevelt's death in 1962. He then sold the property to two young Long Island doctors. In 1977, when they desired to develop the site, there was a groundswell of local support to save Eleanor's home. In 1977, Pres. Jimmy Carter signed the bill designating the site as a National Park Historic Site. This is a current photograph of the two Valkill cottages. (RC.)

The Valkill site is operated by the National Park Service. The stone cottage is used by ERVK (Eleanor Roosevelt at Valkill) for conferences and meetings. There has been a greater appreciation by later generations of the contributions by Eleanor Roosevelt to Hyde Park, the people she knew, the United States, the United Nations, and countries throughout the world. For more information, contact the National Park Service. (RC.)